CHISWICK
THROUGH TIME
Carolyn & Peter
Hammond

AMBERLEY PUBLISHING

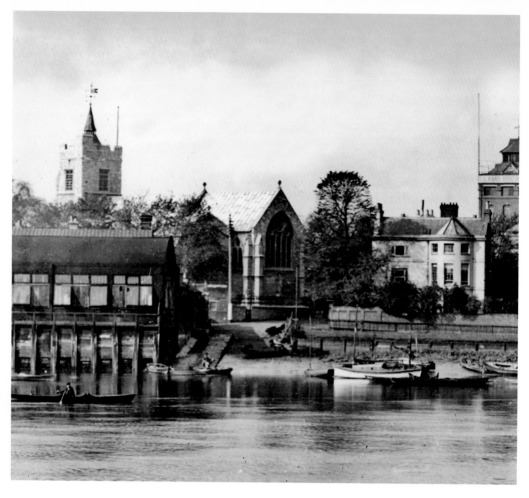

Chiswick seen from across the river in the 1920s.

First published 2010

Amberley Publishing
Cirencester Road, Chalford
Stroud, Gloucestershire, GL6 8PE

www.amberleybooks.com

Copyright © Carolyn & Peter Hammond, 2010

The right of Carolyn & Peter Hammond to be
identified as the Authors of this work has been
asserted in accordance with the Copyrights, Designs
and Patents Act 1988.

ISBN 978-1-84868-052-4

All rights reserved. No part of this book may be
reprinted or reproduced or utilised in any form
or by any electronic, mechanical or other means,
now known or hereafter invented, including
photocopying and recording, or in any information
storage or retrieval system, without the permission
in writing from the Publishers.

British Library Cataloguing in Publication Data.

A catalogue record for this book is available from
the British Library.

Typeset in 9.5pt on 12pt Celeste.
Typesetting by Amberley Publishing.
Printed in the UK.

Contents

Introduction

The earliest images in this book show Chiswick in the first half of the nineteenth century. At that time it was quite rural with fields and market gardens and a population of some 6,000 people living in three small hamlets: Chiswick around St Nicholas' church and along the Mall; Strand on the Green along the riverbank opposite Kew; and Turnham Green along the High Road, the main road to the west of England. Most people who did not work on the land were employed in river-related trades such as boat building and fishing, or in the two breweries. It was only five miles to the centre of London, so the area was popular with the well-off who needed to be near London but preferred the pleasant open spaces of Chiswick. Consequently, many fine houses were built along the High Road and near the river, in addition to the big estates of Chiswick House, Sutton Court and Grove House.

However, things were about to change: London itself was expanding outwards, the first railway through the area was opened in 1849 (unfortunately we could not find any early pictures of this line), horse drawn omnibuses took passengers into London, and by 1901 electric trams had replaced the horse-drawn ones. This made public transport much more affordable so that people could work in London and live in pleasant suburbs such as Chiswick. This all meant more houses were needed, so the market gardens were sold to property developers, most of the big houses were pulled down, their names surviving in the streets that were built over their grounds, and more shops, schools and churches were built. As early as the 1860s and 1870s some new firms who were to become big employers locally were establishing themselves: Thornycroft's shipbuilders on Church Wharf, Chiswick Soap Works (later Chiswick Products) in Burlington Lane, and Sanderson's wallpaper factory in Barley Mow Passage.

There are a wide variety of images in this book, including some paintings and engravings as well as old photographs and postcards. In one or two cases we have used a photograph of poorer quality than normal because it is the only illustration we could find of a vanished building. The pictures are grouped into chapters by subject, creating some interesting contrasts and comparisons, as we follow Chiswick's journey through time from rural hamlets to cosmopolitan London suburb.

CHAPTER 1

Houses Great and Small

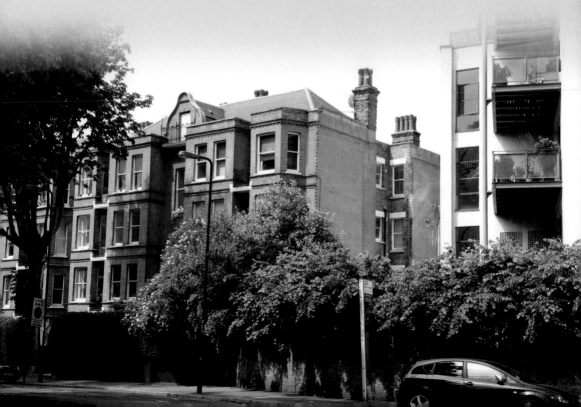

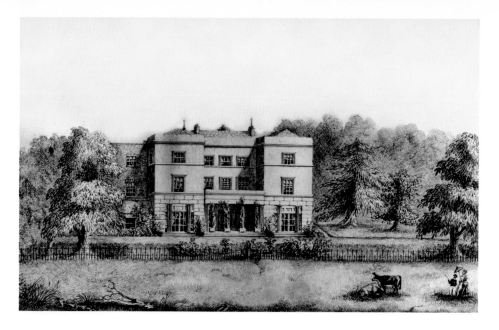

Arlington House

An early Victorian view of this late eighteenth-century house on the west side of Turnham Green. When the house was demolished in the 1870s, Arlington Park Gardens and Walpole Gardens were built on its extensive grounds. The flats of Arlington Park Mansions were developed on the remainder of its site and that of its neighbour, The Chestnuts, in about 1905.

(On previous page) Acton Green Lodge

The flats of Fairlawn Court and Evershed & Vignoles' factory were built on the site of this house in Acton Lane. After the factory closed in the 1990s, the modern flats on the right called Chiswick Green Studios were built there.

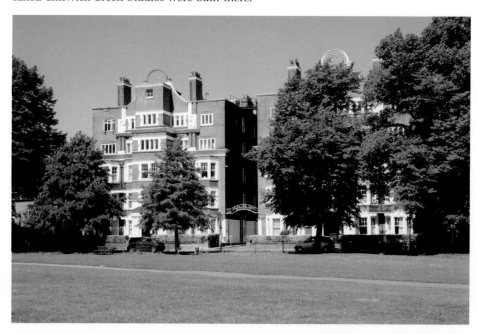

Bedford House

The early photograph below shows Bedford House, built in 1793 by Mr John Bedford. From 1836 until his death in 1865 it was the home of Dr John Lindley, Assistant Secretary of the Royal Horticultural Society. By the 1920s the house had been divided into flats, and in 1924 the shops of Bedford Corner were developed around it. It lost its extensions, but the oriel window of the east wing is still just visible on the right.

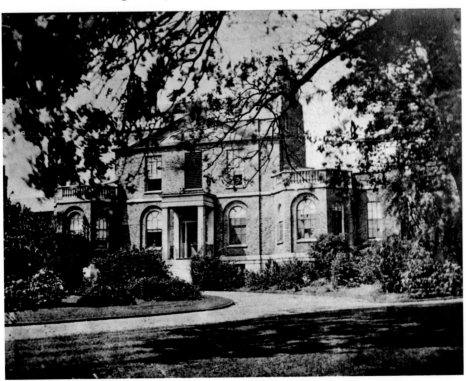

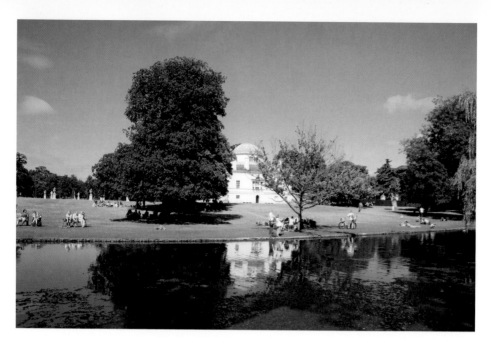

Chiswick House

The photograph below was taken in 1948, the year the Ministry of Works took over ownership of Chiswick House. Years of minimal maintenance and wartime damage had taken their toll, and it was decided to remove the two wings that had been added to the original villa in the 1780s. Work commenced on this in 1950, and the side of the house shown in the old photograph was rebuilt according to its original appearance.

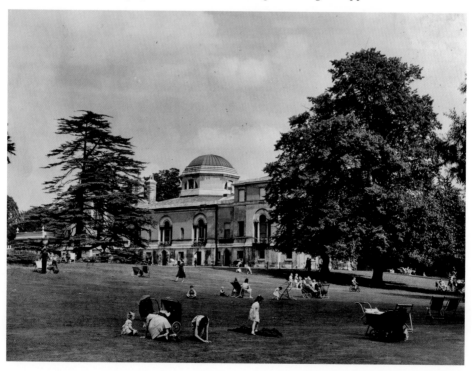

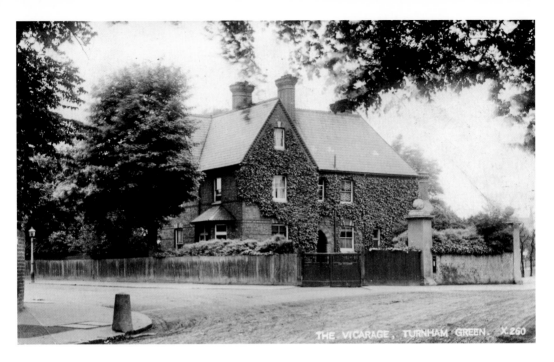

Christ Church Vicarage

An early photograph of the vicarage, built for the vicar of Christ Church in the middle of the nineteenth century. It was on the site of Heathfield House, whose tall gateposts were incorporated into its garden wall. A large, rambling building, it was replaced by a more modern vicarage in Wellesley Road, and a new fire station was built on its site in 1964. The modern photograph shows the church hall just to the east, opened in 1914.

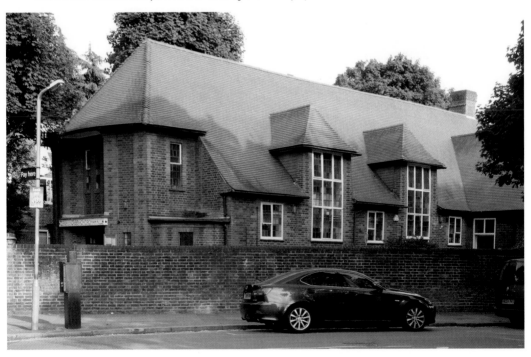

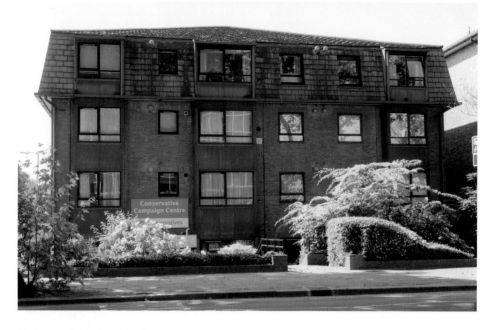

Conservative Party Headquarters

The photograph below shows the local Conservative Party HQ in 1967, on the corner of Oxford Road North and the High Road. It was built as a private house in the 1860s and called Cromwell House. For many years it was the home of the local doctor, until the Conservative Party took it over in the mid 1930s. Because of rising costs it was rebuilt in the 1980s as flats and offices with a smaller Conservative Party office incorporated.

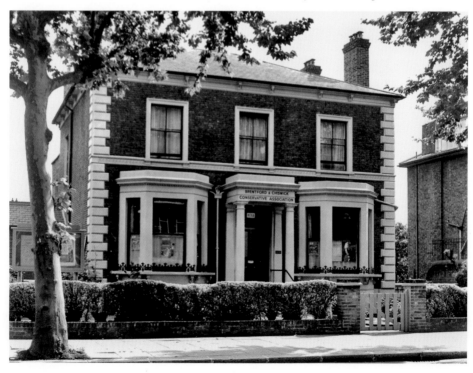

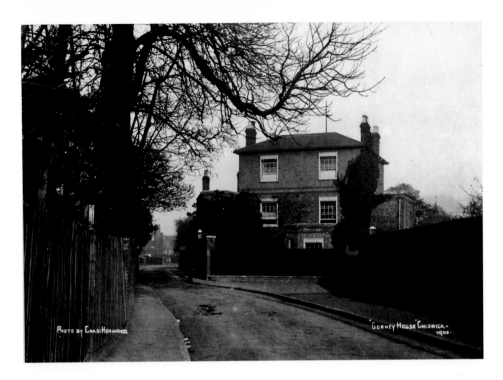

Corney House

Corney House in 1905. This is not the original Corney House, which was nearer the river and was demolished in 1832, but a Victorian house built on the corner of Powell's Walk and Burlington Lane. The house was demolished when Burlington Lane was widened in the 1930s to take the traffic over the newly built Chiswick Bridge. The modern photograph shows the road has been widened again for the Hogarth Flyover over the roundabout.

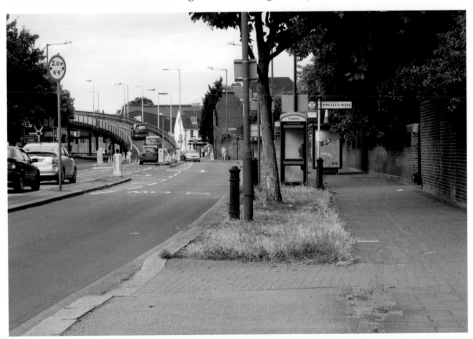

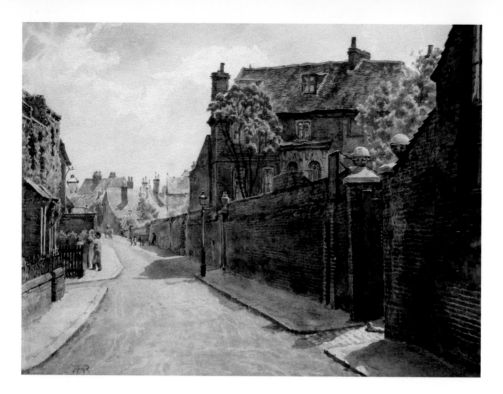

Hogarth House

A watercolour of Hogarth Lane in 1897, painted by local artist T. M. Rooke, when it was still a quiet country lane. The painter and engraver William Hogarth used the house as his summer residence from 1749 until his death in 1764. After the Second World War the lane was expanded into the six-lane A4 trunk road, but fortunately the house survived, protected by its high garden wall, and will re-open to the public in 2011 after major refurbishment.

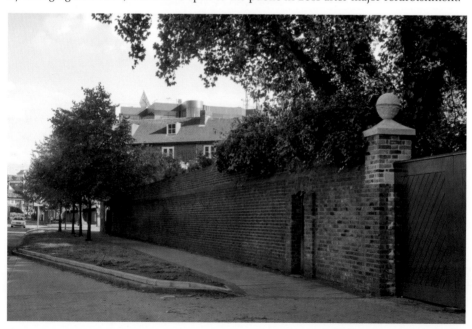

Kensington House

Kensington House in 1928, on the east side of Turnham Green Terrace. The Terrace once contained several eighteenth-century and nineteenth-century houses, set back from the road in their own gardens. Kensington House was one of the last ones to survive, and was replaced by the shops and offices of Gable House in the early 1960s. As with some other large houses locally, once it was no longer viable as a private house it was turned into a school. It was a school for fifty years from the 1860s, firstly as the Chiswick Collegiate School run by Dr William White, and from the 1890s as the Kensington House High School for Girls, run by Miss Charlton and Miss Layton. The school playground was on the opposite side of the road, as the single-storey shops on the west side were not built until early in the twentieth century.

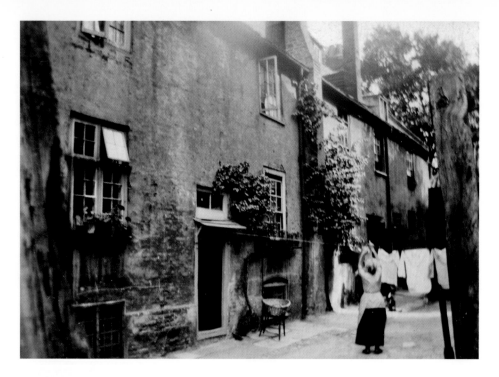

Lamb Yard

Cottages in Lamb Yard, off Church Street, in the 1920s. They were said to be over 300 years old and would have been occupied by workers from the Lamb Brewery that towered above them. The brewery itself closed in 1920, and the cottages were swept away some time after that. Originally there was a way through from Lamb Yard to Chiswick Lane. Now offices have replaced the cottages.

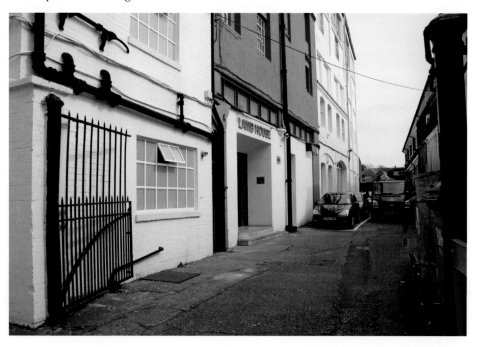

Mills Row

The photograph below shows Mills Row, off Bridge Street, in the 1950s, when the area was ripe for redevelopment, although this did not happen until some twenty years later. These little two-up two-down cottages, each with a privy at the bottom of the garden, were built in the early nineteenth century and named after Mr Mills, who owned them in the Victorian period. The modern photograph shows the residential development that has replaced them.

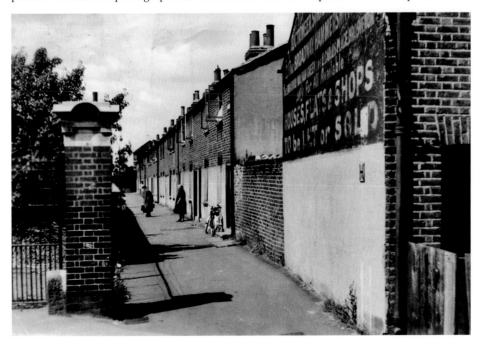

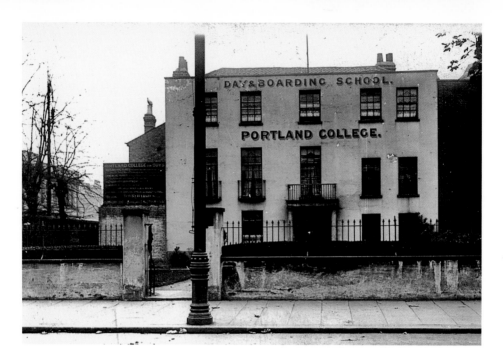

Portland House

Portland College, photographed before the First World War. It was described as 'an old-established high class day and boarding school for boys and girls, boasting separate class rooms with up-to-date furniture and appliances, and a large playground and field for games'. The house would have been built for a well-off family with servants, but it had become a school by the middle of the nineteenth century, which closed during the First World War. The building is now a restaurant called Frankie's.

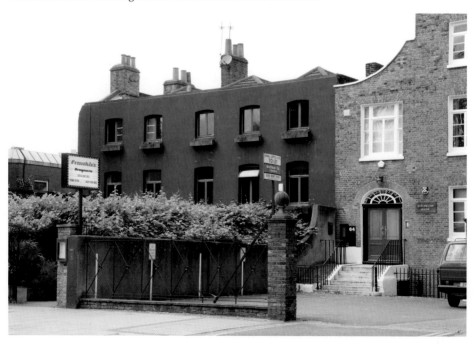

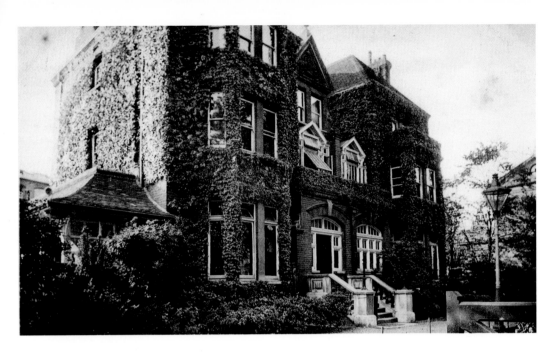

Public Library

An Edwardian postcard showing the public library in Duke's Avenue, when the main entrance was up an imposing flight of steps in the middle of the frontage. This house was built for the Sanderson family in the 1880s, conveniently close to their wallpaper factory in Barley Mow Passage. In 1897 they gave the house to be used as a public library, and the library has been there ever since. After being badly damaged in the 1928 fire at Sanderson's factory, it was renovated and a large extension added on the left.

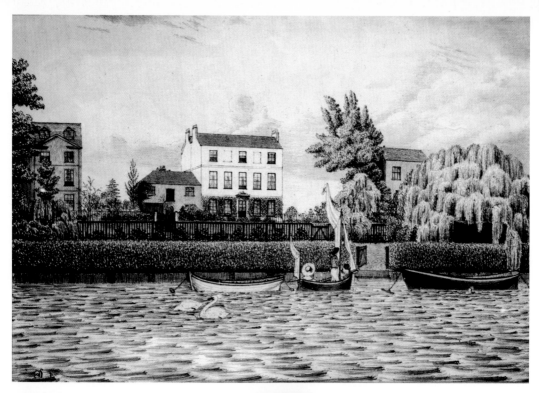

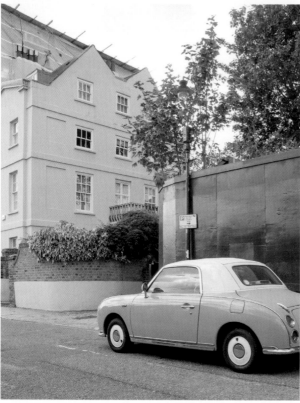

Rothbury House

A lithograph of 1837 showing Rothbury House on Chiswick Mall, with the house called The Osiers on the left. This was the home of Benjamin Sharpe, and later of his daughter Elizabeth Isabella, drawn by his son John Charles Sharpe, possibly as a reminder of childhood sailing trips in the family's boat. In 1912 Dan Mason, the chairman of the Chiswick Polish Company (later Chiswick Products), gave the money to build a cottage hospital for the people of Chiswick in the grounds of Rothbury House. In the 1930s the house was pulled down to make room for a larger hospital, which sadly closed as a hospital in 1975, although it survived for some years as a home for the sick and elderly. The modern photograph shows that The Osiers remains, but hoardings now surround the site of the demolished hospital. There are plans to build housing there.

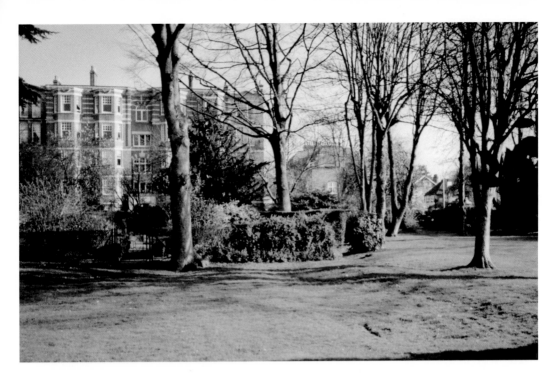

Sutton Court

These mansion flats were built at the beginning of the twentieth century on the site of Sutton Court, the old manor house whose most famous resident was Lady Mary Fauconberg, daughter of Oliver Cromwell. One of the selling points for the new flats was the attractive grounds which surrounded the buildings, containing formal flower gardens, a rustic bridge and tennis courts, shown in the Edwardian postcard of the grounds below. Happily the residents still take a pride in the gardens.

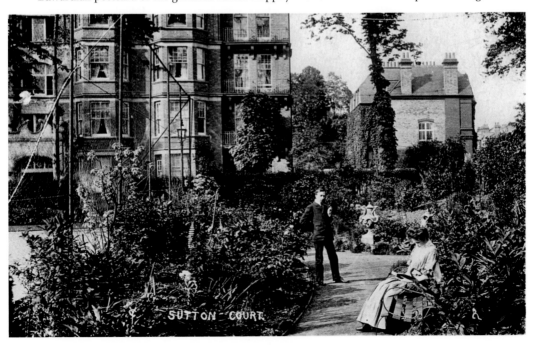

SUTTON COURT

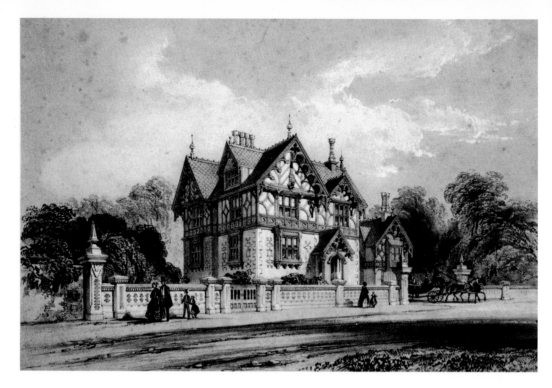

Sutton Lodge

An 1840s print of what was described as a 'Cottage' in 'Elizabethan Gothic' style, built for George Spencer Ridgway, who was the Duke of Devonshire's receiver. The house, which he called Burlington Cottage, was in Heathfield Terrace, overlooking the western end of Turnham Green. It was later known as Sutton Lodge, and survived until the 1950s. It was replaced by the block of flats called Sandown Court.

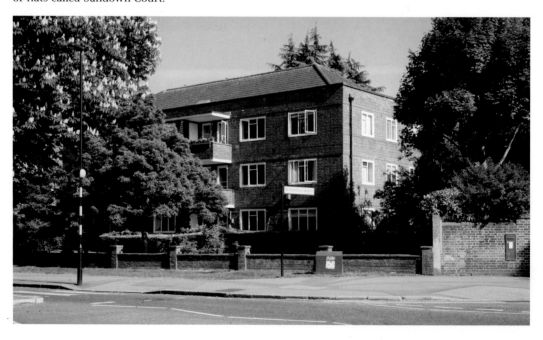

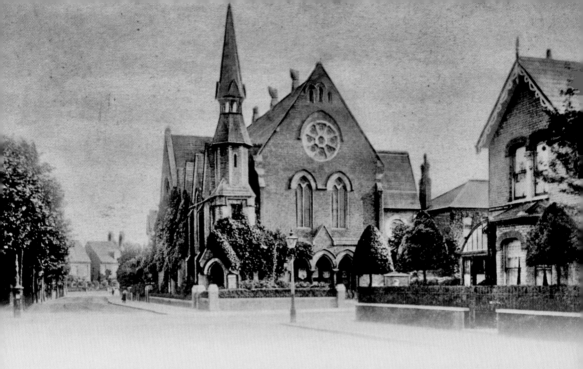

CHAPTER 2

Churches and Chapels

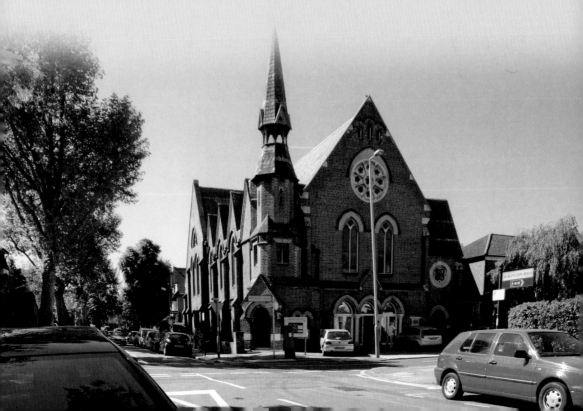

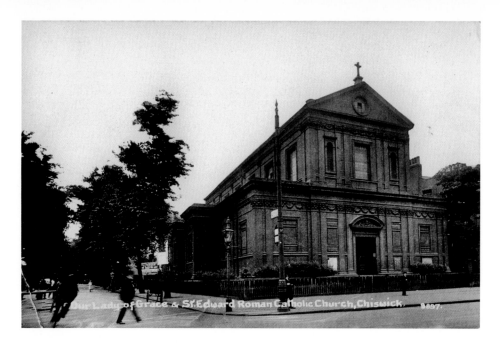

Catholic Church

An early twentieth-century postcard of the church, dedicated to Our Lady of Grace and St Edward, which was built on the corner of Duke's Avenue and the High Road in 1886, replacing a smaller Catholic church on the same site. The modern photograph shows the tower that was added in 1930 as a memorial to parishioners killed in the First World War.

(On previous page) Gunnersbury Baptist Church.

The church was built in 1877 on the corner of Wellesley Road and Burlington Road to replace an earlier iron chapel. The church still flourishes today.

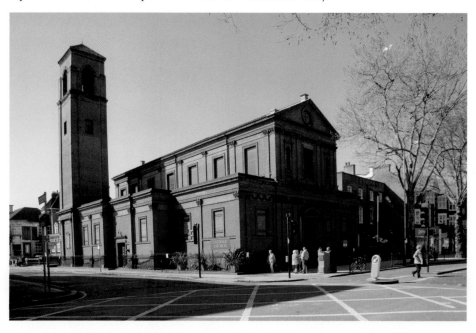

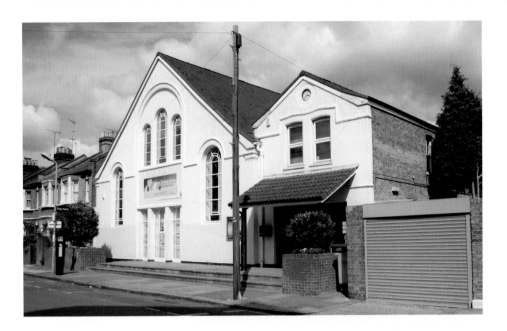

Chiswick Mission

The Chiswick Mission building shown in the 1960s photograph below was opened in 1891 in Fraser Street. It provided Sunday schools, non-sectarian worship and help for the poor. It had its origins in the coffee stall set up by Mr Robert Thomson Smith for Thornycroft's workers to tempt them away from the local pubs. Mr Smith continued to be involved with the Mission until 1913. The modern photograph shows it has now become the Chiswick Christian Centre.

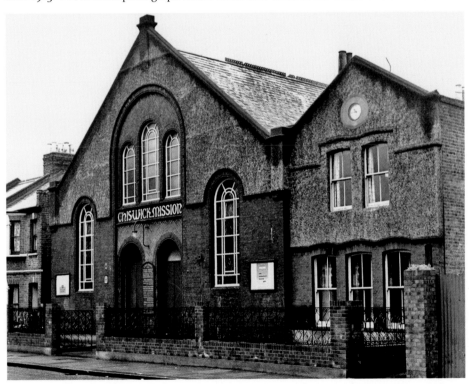

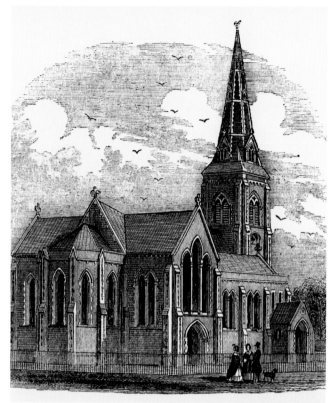

Christ Church, Turnham Green
An engraving from a magazine published in 1844, describing the consecration of the new church in the previous year. It was designed by Sir George Gilbert Scott in dark flint with stone dressings in a 'Victorian Gothic' style, and consisted of a tower, nave, transepts and a hexagonal apse for the altar. With galleries down each side of the nave it could seat 940 people and provided a place of worship for the growing population who lived in the north of the parish – the first new Anglican church to be built to supplement the original parish church of St Nicholas by the river. In 1887 a chancel and north-east chapel were added to the church, as shown in the modern photograph.

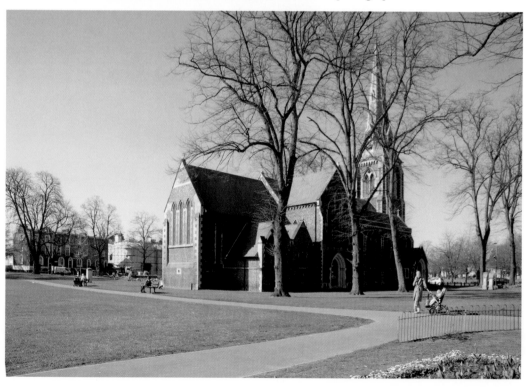

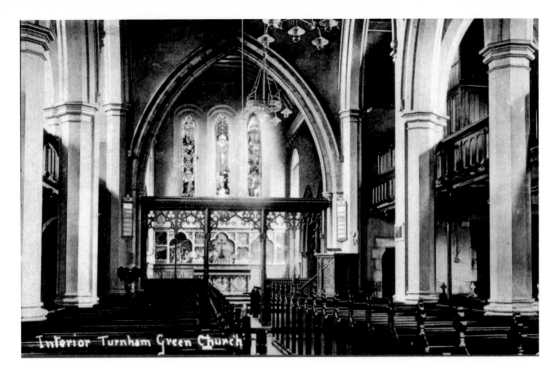

Interior Turnham Green Church

Interior of Christ Church

An early postcard showing the carved screen, pulpit and choir stalls which were installed in 1906. They were carved in English oak by six members of the congregation who attended wood-carving classes at Chiswick Polytechnic for four years to carry out the work. The modern view shows how much lighter and more spacious the church appears after chairs replaced the pews, the galleries were removed in the 1990s, and the interior was re-modelled for the Millenium.

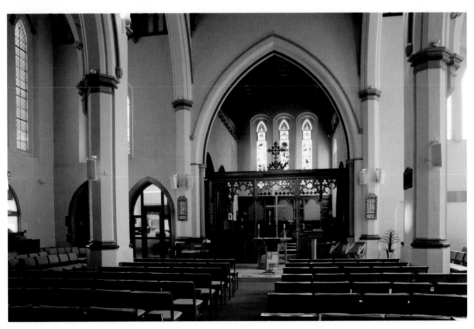

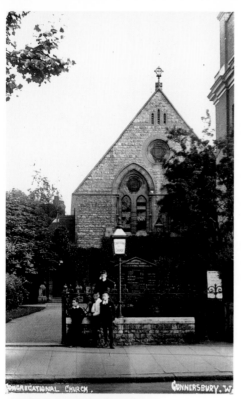

Congregational Church

Congregational Church

The Congregational church on the south side of
the High Road almost opposite Chiswick Road
early last century. The first Congregational
church on this site was an iron church opened
in 1875; it was here that the young Vincent Van
Gogh taught Sunday school classes during his
brief stay in England in 1876. The church in the
photograph was built on the east side of the
iron church in 1881 to provide more room for
the growing number of worshippers – it could
seat 500 people. The iron church remained
in use as a church hall until 1909. The stone
church was closed in 1974, and demolished in
the early 1980s to make way for the office block
called Bond House and its garden.

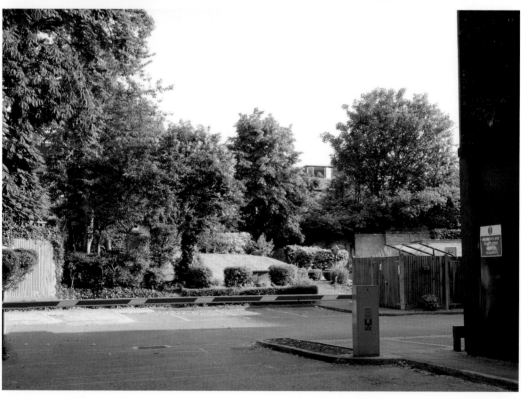

Emmanuel Church

The early photograph below shows the iron building of the Emmanuel Reformed Episcopal church, erected on the north side of Wellesley Road between Grange Road and Burlington Road in 1890. This supplemented their earlier iron building just to the west of the railway, which then became the Sunday school room. Many of the local churches started out in an iron building as they were relatively cheap and quick to erect. They could then be sold on when the congregation had raised sufficient funds to build a more solid edifice of brick or stone, or retained as halls or schoolrooms. Unusually, the Emmanuel church never replaced its iron buildings. Regular services here ceased during the Second World War, and the building was demolished in 1949. A block of flats called Wellesley Court was built on the site in the 1970s.

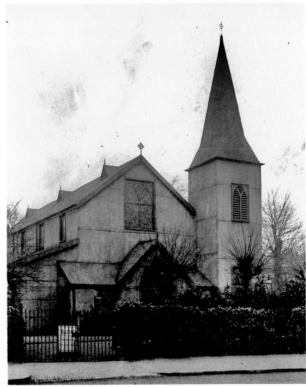

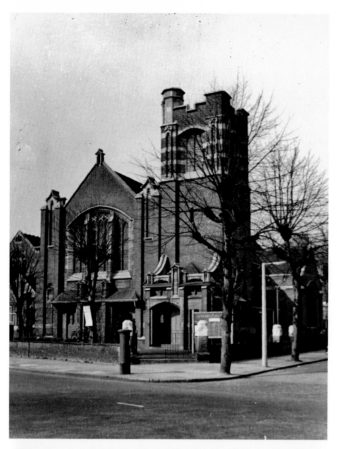

Methodist Church

Methodists have been worshipping in Chiswick from the middle of the nineteenth century onwards. They acquired a site on the corner of Sutton Court Road and Barrowgate Road from the Duke of Devonshire and built a chapel there which opened in 1880. By 1909 they had raised enough money to build the large church shown in this 1964 photograph. It was built in red brick with stone dressings, and could seat 800 people. The earlier chapel on the south of the site then became the church hall. In the 1980s the Methodists sold the north part of the site for housing, cleared the rest of the site and built a new smaller church, which opened in 1988. The modern photograph shows this new church and the new church hall built in 2003.

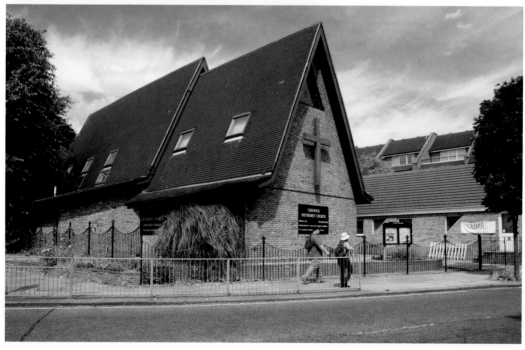

St James' Church

The photograph below shows St James' church in 1965, on the north side of the High Road opposite Cambridge Road. The church was built in 1887 on land given by the Rothschild family of Gunnersbury Park. It closed in 1986 and was demolished three years later. A large office block was built on its site, which is now the Cultural Office of the Royal Embassy of Saudi Arabia.

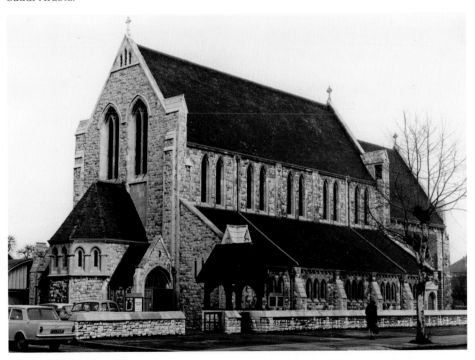

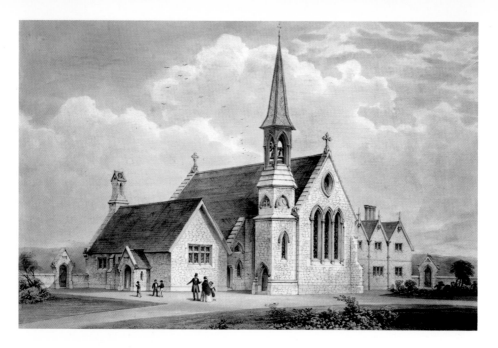

St Mary Magdalene's Church

A lithograph of the chapel and schools of St Mary Magdalene, erected in Bennett Street in 1848. They were designed and financed by local banker, John Charles Sharpe, and built to serve the population of Chiswick New Town. The church was rebuilt in 1894, but damaged during the Second World War, and closed in 1944. It was demolished in 1956 and the site used for a new church hall for St Nicholas'. This was demolished in its turn and a block of flats called Magdalen House is now on the site.

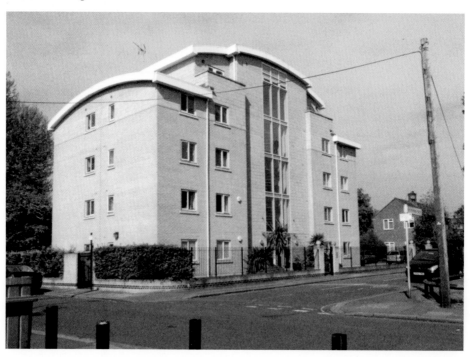

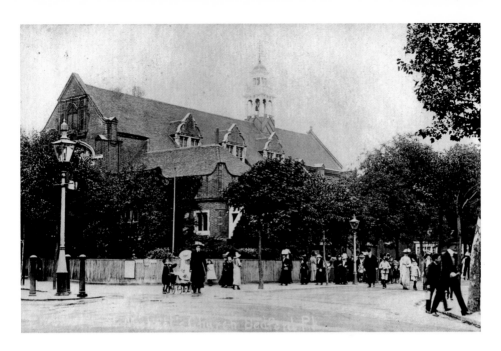

St Michael and All Angels' Church

A postcard from about the time of the First World War showing the congregation leaving the church of St Michael and All Angels after a service. The church was built to serve the emerging aesthetic suburb of Bedford Park and was consecrated in 1880. It was designed by Richard Norman Shaw, the architect who also supplied plans for some of the houses in Bedford Park. The modern photograph shows that the building has not changed much externally.

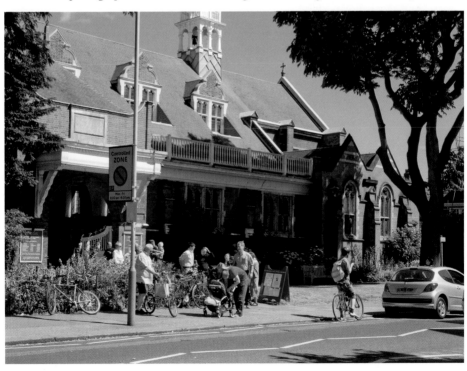

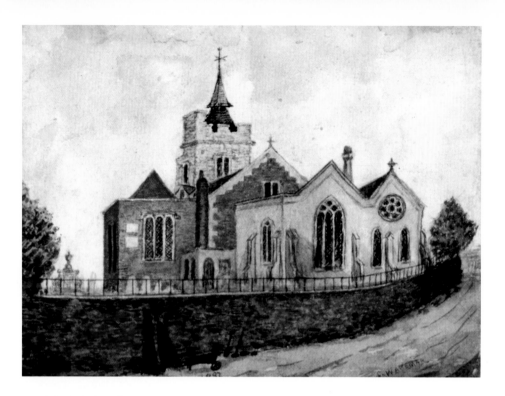

St Nicholas' Church

A watercolour of St Nicholas' church signed 'C. Wakeman', and painted in 1882, just before the old church was demolished. There has been a church on this site serving the original parish of Chiswick since at least the twelfth century – built, extended, and rebuilt several times. The painting shows how the tower, nave, side aisles and chancel were all built at different dates. Everything except the medieval tower was demolished and rebuilt in the Perpendicular style in 1882–4, designed by the architect J. L. Pearson.

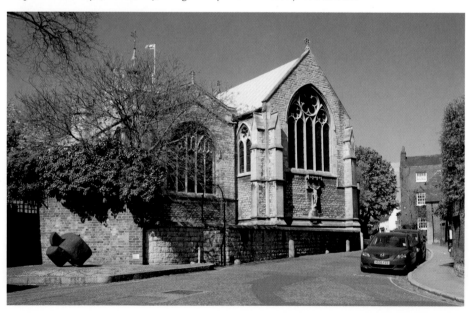

Interior of St Nicholas' Church
The interior of St Nicholas' church looking west towards the medieval tower with the bell ropes hanging down in loops, photographed in 1880, not long before the rebuilding project started in 1882. The stained-glass window in the tower was retained. It depicts scenes from the Bible which include children, and was installed in 1877 in memory of the Principal of Bradmore House School in Chiswick Lane. The monuments and memorial tablets were taken down and re-erected in the new building and the old galleries and box pews were swept away and replaced by Victorian bench pews. The elegant marble font was recycled – it forms the basin inside the heavier stone font shown in the modern photograph.

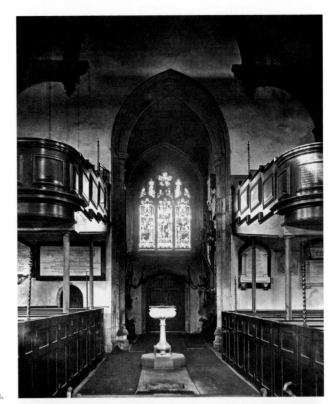

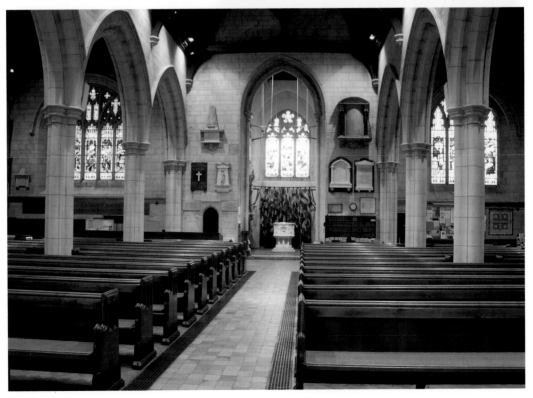

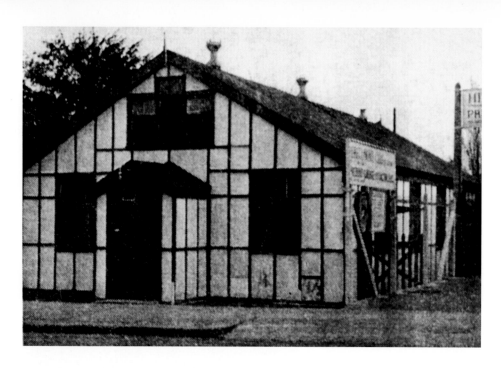

Seventh Day Adventists' Church

A newspaper photograph of the Seventh Day Adventists' church in 1967, on the south side of Stamford Brook Road. This was a wooden structure dating from 1916, with a separate brick-built hall at the rear. It was destroyed in a disastrous fire in 1971. However, the congregation raised the money for rebuilding and the modern photograph shows the new church which was opened in 1974 on the same site.

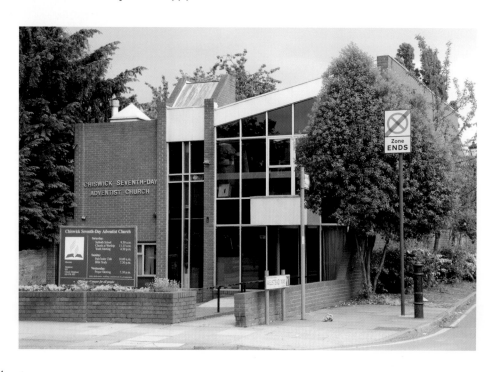

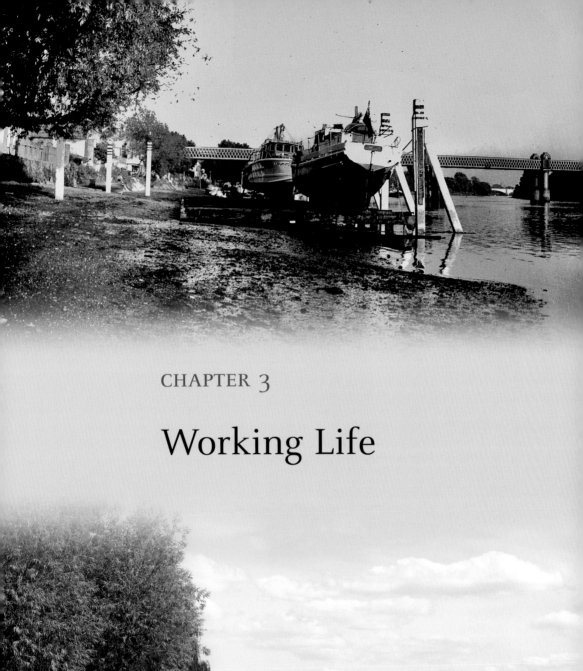

CHAPTER 3

Working Life

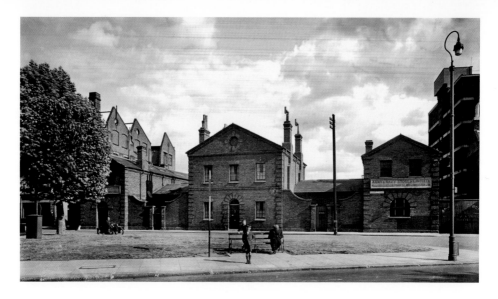

Army and Navy Depository
The entrance buildings of the former militia barracks in Heathfield Terrace, photographed in the late 1940s. The barracks had been erected for the Third Middlesex Militia (the Victorian equivalent of the Territorial Army) in 1855. After the Militia left, the Army and Navy Stores took the site over in the 1880s, erecting large warehouses for storing furniture, but retaining the original entrance buildings. The site was redeveloped in the 1980s for the offices and flats of Devonhurst Place.

(On previous page) Boat building at Strand on the Green
In the past there were several firms of boat and barge builders at Strand on the Green. This 1961 photograph shows the boat rest in front of Magnolia Wharf still occupied, but now it is seldom used.

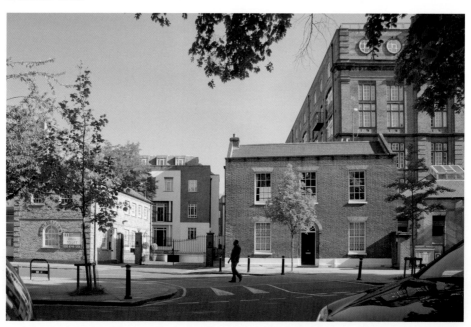

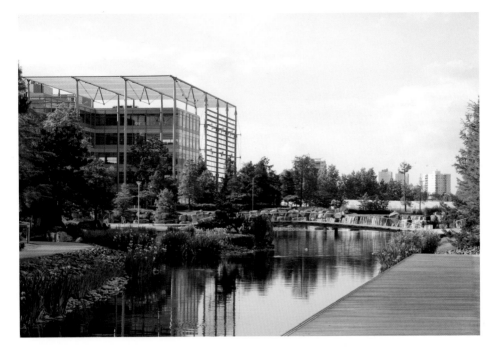

London General Omnibus Company

The LGOC established its bus repair works on Chiswick High Road opposite Gunnersbury station in 1921. The photograph below shows the test slope in the 1930s – every bus chassis was driven up and down the slope to test its brakes and engine capacity. The bus works, which also included research laboratories and driver training facilities, was closed down in 1988. The site lay unused for over ten years and was then redeveloped as the Chiswick Business Park, where office blocks are set in landscaped grounds.

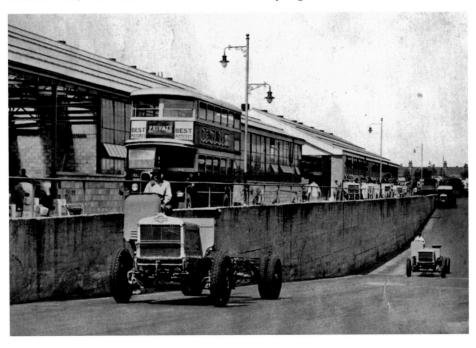

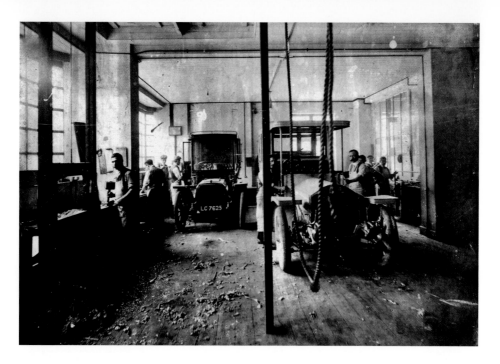

Mulliner's Coach Works

The car-body workshop at Mulliner's coach works before the First World War. Mulliner's moved into the Bath Road building that had been the Bedford Park Stores in 1906. They hand crafted car bodies for firms such as Rolls Royce and Daimler. They merged with Park Ward in 1961 and moved to Willesden in 1969. The building was later converted to office use.

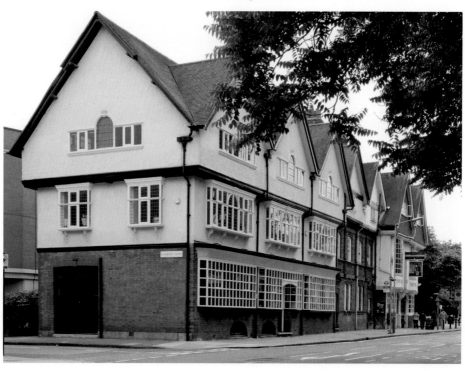

Police Station

The police station on the corner of Windmill Road and the High Road in about 1908. Chiswick's first police station was also on the north side of the High Road but a little further west. The building shown on this postcard was purpose-built for the police and opened in 1872. At that date the entrance door was on the left side of the frontage, and the royal arms were over a central window. One hundred years later the police moved to new premises on the opposite side of the High Road and the building became offices. The high barred windows of the original cells can be seen in the single-storey back extension on the left. One of the cells became a wine store and the others became private dining areas when the building was converted into Carvosso's restaurant and wine bar in 2006.

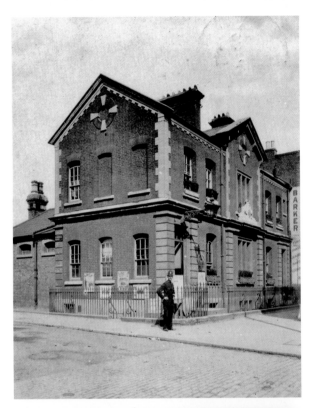

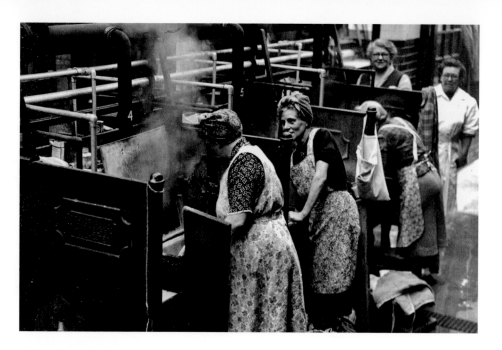

Public Wash House

A 1940s photograph of the washing area of the public baths and wash house opened by Chiswick Council in Bridge Street in 1924. This provided slipper baths for those with no bathroom at home, and facilities where the week's laundry could be washed, rinsed, spun and dried in about two hours instead of taking two days' hard work at home, with the added attraction of a chat with your friends. Nowadays, launderettes such as this one in the High Road offer the same service.

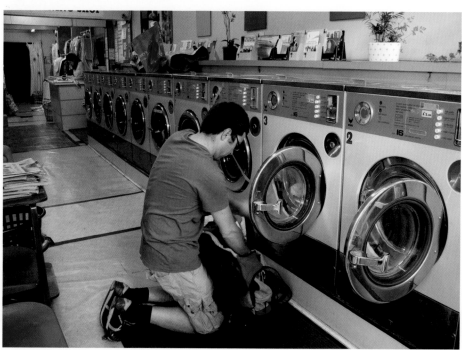

Redex Garage

The first petrol station on the corner of Marlborough Road and the High Road was built in the late 1930s, catering for the growing popularity of motoring and providing a base for the 'Clock Tower Club'. The photograph below shows it in the 1950s when it was the Redex Model Service Station, and headquarters for Redex fuel additives. It later became an Elf service station. The garage closed a few years ago, and a new development of flats has recently been completed on its site.

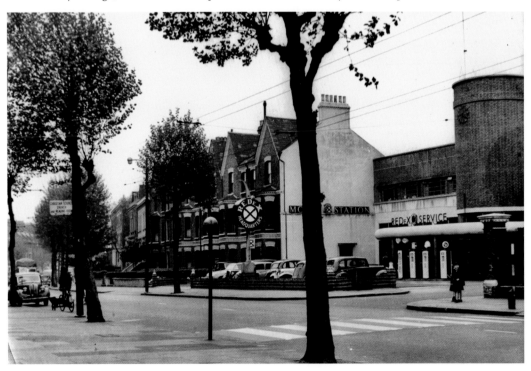

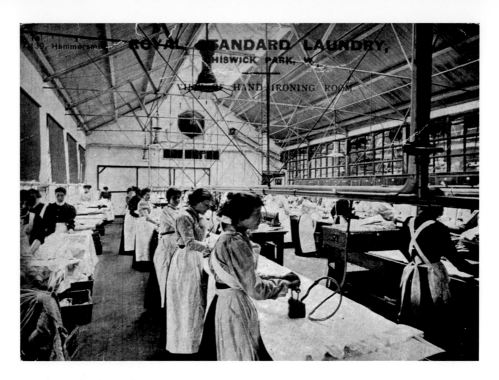

Royal Standard Laundry

An Edwardian postcard of the hand ironing room at the Royal Standard Laundry; the girls are using irons heated by a gas flame inside the body of the iron. This laundry was established in about 1899 in Bollo Lane and was known for its fine work. At the height of its prosperity it had several collection points in the area and a fleet of vans for delivering the clean washing. It closed in the 1970s and the site is now a warehouse.

Arthur Sanderson & Sons

Arthur Sanderson established his wallpaper factory in Barley Mow Passage in 1879. He died in 1882 but the firm prospered under his sons and they extended the buildings on the south side of the passage and opened a new block on the north side in 1904. They were one of the biggest employers locally, with over 1,000 staff. The photograph below shows the factory in about 1900; the left-hand gatepost of their entrance can still be seen below the signs for Sam's.

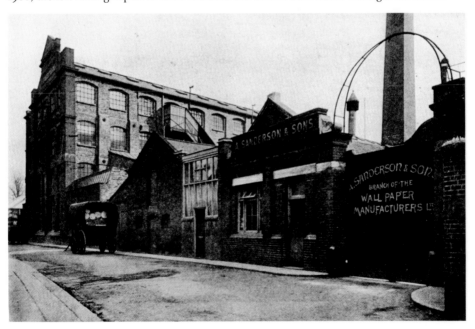

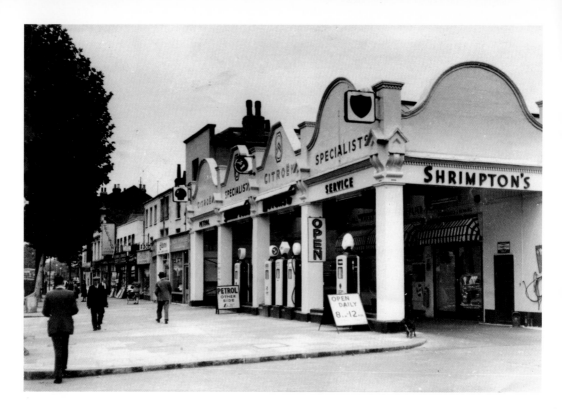

Shrimpton's Garage

Shrimpton's garage in the 1950s. A garage has existed here on the corner of Brackley Road and the High Road since 1905, but not always run by the same firm. In the mid-1990s a small branch of the Somerfield supermarket chain opened at the back of the site; it remained in business for about ten years. Currently the buildings have all been demolished but the site remains empty and undeveloped.

Thornycroft's

John Isaac Thornycroft set up his shipbuilding works on Church Wharf in the 1860s. The company produced several hundred naval vessels and pleasure craft during the forty years it was based in Chiswick. The postcard below shows the main gate with the foundry and the mess room in the background. The works moved to Southampton in 1904 when its boats became too large to fit under the bridges downstream. The site had various other industrial uses, and was redeveloped as Georgian-style housing in the 1980s.

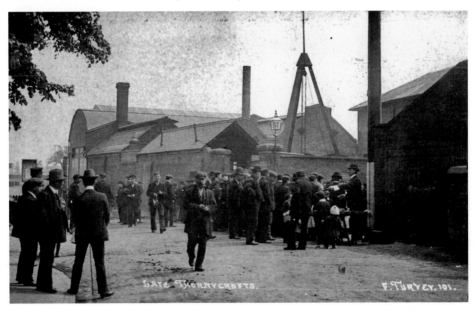

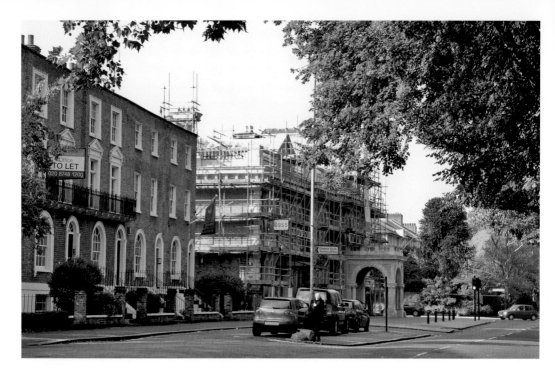

Town Hall

The postcard below shows the town hall in Heathfield Terrace in the 1920s. It was built in 1876 and enlarged in 1900, and remained in use as the centre of the administration of the area until Chiswick became part of the London Borough of Hounslow in 1965. It now houses some council offices and the Citizens' Advice Bureau, and is also used by many local groups. The early nineteenth-century houses next door were restored in 1976.

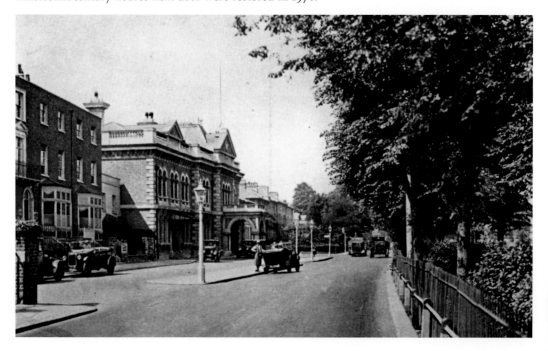

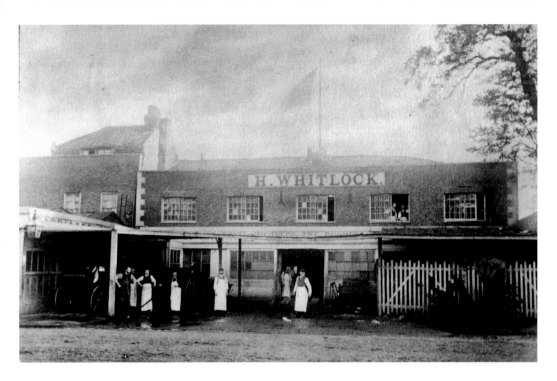

Whitlock's Coach Works

The coach works in the 1890s. Mr Henry Whitlock's coach-making business was established in 1778 in premises on the south side of the High Road just east of Chiswick Lane. He proudly advertised his warrant to supply coaches to HRH the Duchess of Kent, the mother of Queen Victoria. The business moved to the north side of the High Road when Homefield Road was developed in the 1890s on some of the ground the works once occupied.

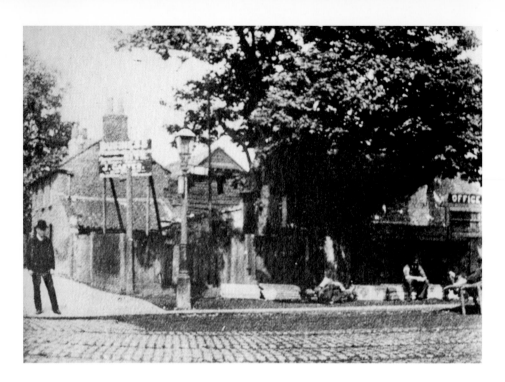

Young's Corner

This rare photograph of 1891 shows the site of the farm and market garden on the north-west side of the junction of the High Road and the Goldhawk Road just as the buildings were being demolished for the redevelopment of Young's Corner. Thirteen acres of orchards and market garden had originally stretched northwards on the west side of the Goldhawk Road, with Mr Young's grocery shop on the opposite corner. A substantial parade of shops with accommodation above replaced the open fields in 1894.

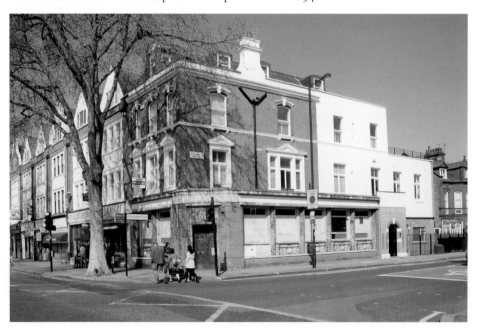

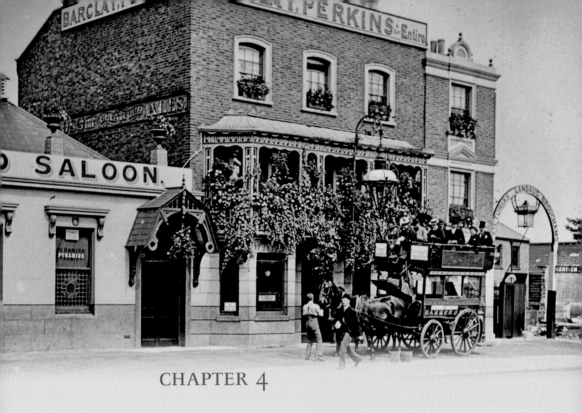

CHAPTER 4

Leisure Time

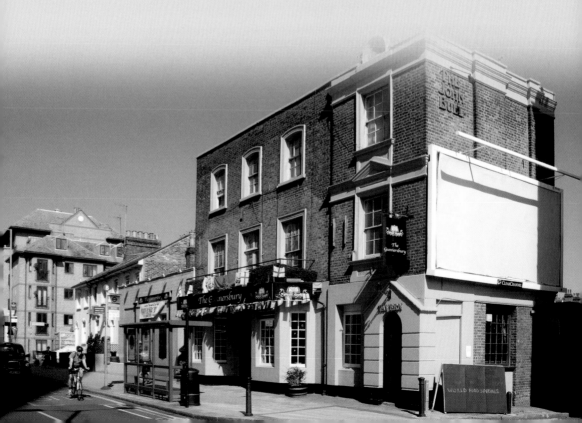

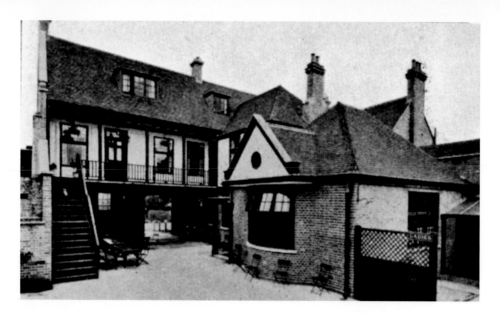

Crown Inn

The courtyard of the Crown Inn in the 1950s. It was an eighteenth-century coaching inn on the south side of the High Road which was rebuilt in the 1920s retaining the 'coaching inn' style, complete with an arched carriage entrance leading into the courtyard. It was demolished in 1957 to make way for the Chiswick roundabout. The modern photograph shows the area that would have been the inn's courtyard.

(On previous page) John Bull

A horse bus outside the John Bull pub opposite Gunnersbury station at the end of the nineteenth century. The pub has now become The Gunnersbury.

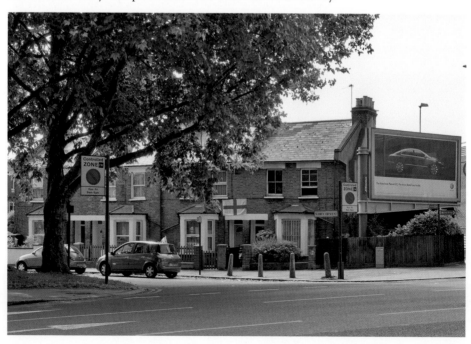

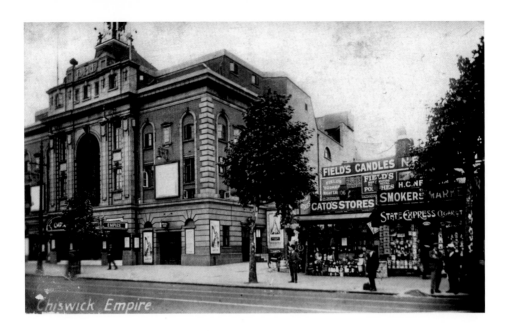

Chiswick Empire

Sir Oswald Stoll commissioned Frank Matcham to design a theatre for the High Road, and the Chiswick Empire opened in 1912. This postcard was probably published soon after that. William Cato's second hardware store, opened in 1905, was next door. The Empire provided entertainment ranging from music hall acts to opera and Shakespeare, but despite its popularity it closed in 1959 and was immediately demolished. A parade of shops was built on its site, with a large office block called Empire House towering over them.

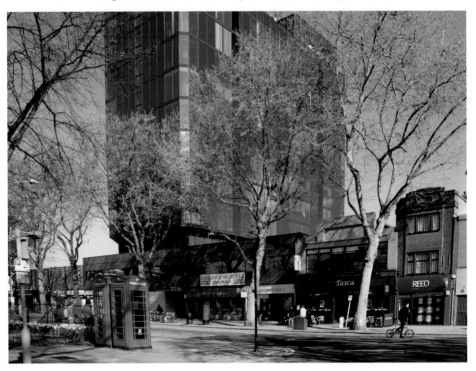

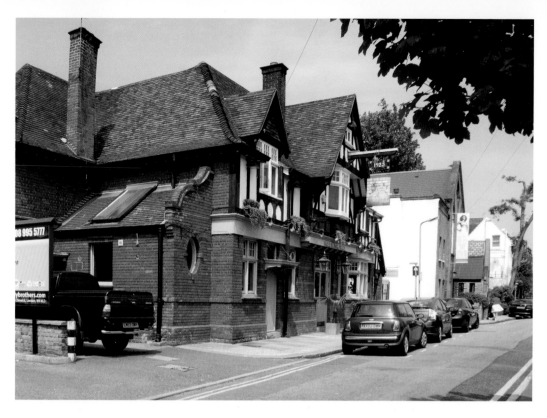

The Hole in the Wall

The postcard below, dating from about 1910, shows the Queen's Head in Sutton Lane, known unofficially as the Hole in the Wall. A pub of that name was licensed as early as the 1720s. The modern photograph shows a different building as the pub was rebuilt in 1925 and is now a gastropub with a beer garden behind.

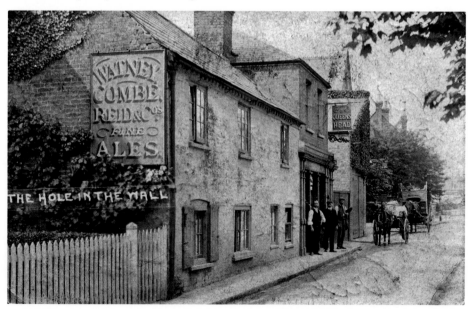

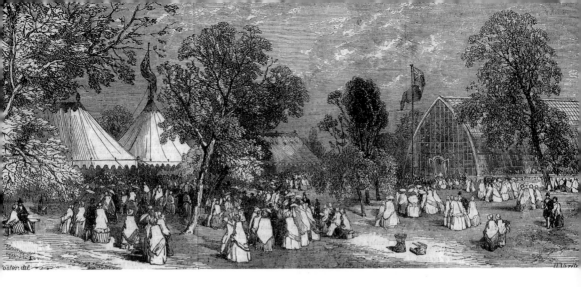

Horticultural Society Fête

An engraving of a fête held by the Horticultural Society in 1849 to show off the fruit and plants they were growing in their Chiswick gardens. The Society (it didn't become 'Royal' until 1861) leased 33 acres of land from the Duke of Devonshire in 1821, south of the High Road and bounded by Duke's Avenue and Sutton Court Road. Their fêtes became popular social occasions. The modern photograph shows the extent of their gardens, built over with streets of Edwardian houses after the society moved to Wisley in 1903–1904.

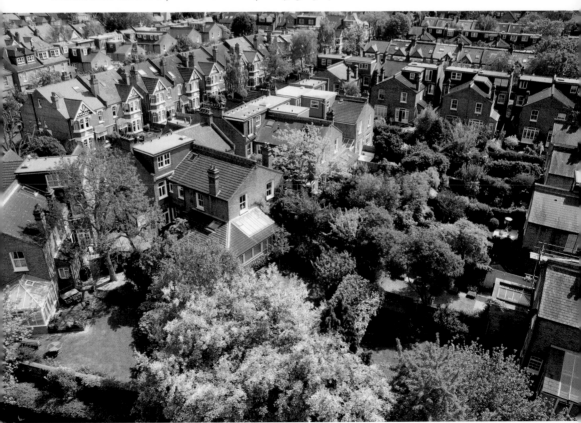

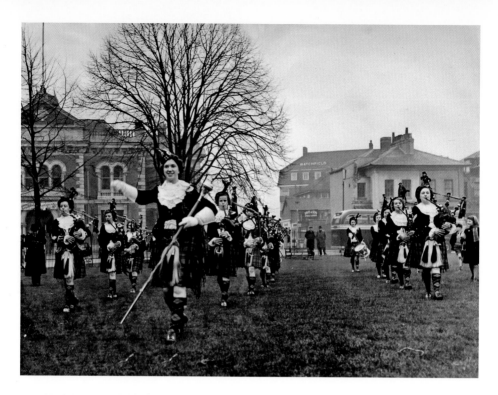

Turnham Green Common

The Dagenham Girl Pipers countermarching on Turnham Green to publicise the start of National Savings Week in 1955. This was their Silver Jubilee year as they were founded in 1930, the first female pipe band in the world. The Green has often been used for special events, fundraising and sporting activities. The modern photograph shows visitors enjoying George Irvin's Fair on a Saturday afternoon in the summer.

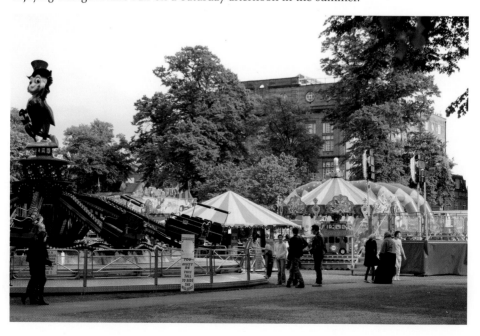

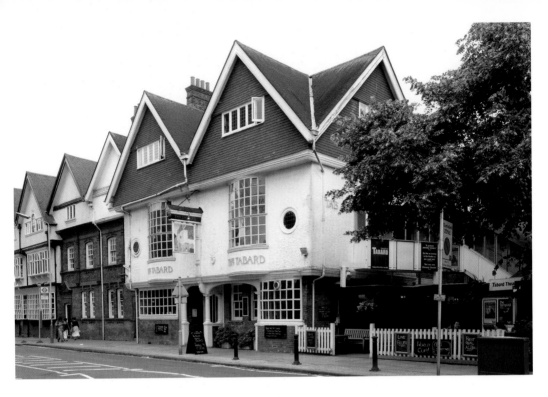

The Tabard

The attractive postcard below shows the Tabard in Bath Road about the time of the First World War. It was designed by the architect Richard Norman Shaw, who also designed St Michael and All Angels' church and some of the houses. It opened in 1880, one of the first public buildings to serve the newly emerging suburb of Bedford Park. The modern photograph shows that, unlike many local pubs, it has survived without being either rebuilt or renamed.

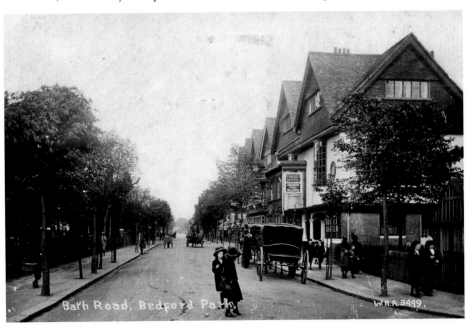

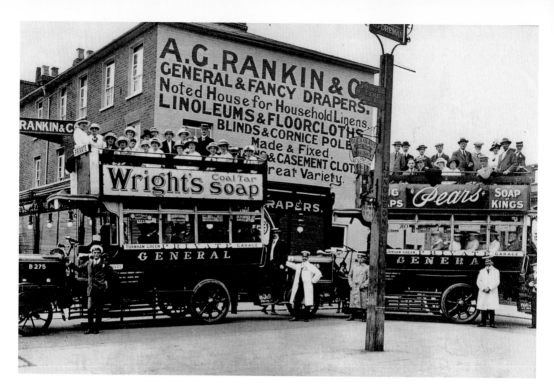

Coach Outings

Outside the Windmill pub on the corner of Windmill Road and the High Road is a group of Rankin's staff about to depart for a day out in about 1912. Rankin's drapery shop had been established in the 1860s next door to the Windmill and continued for a hundred years before selling out to Salem's carpet shop. The modern photograph shows members of the Brentford and Chiswick Local History Society boarding the coach for their annual summer outing in July 2010.

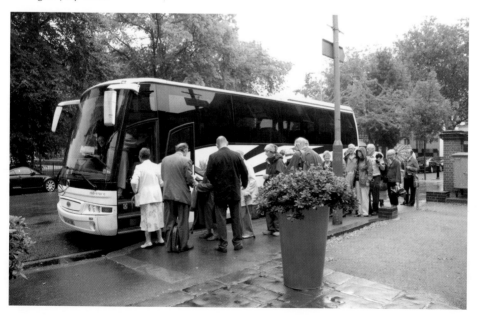

The Windmill

An oil painting of the Windmill pub in the late 1880s. There has been a pub on this site since the early eighteenth century – the date on the sundial is 1717. This building was demolished in about 1900 and replaced by a splendid Edwardian edifice, which itself succumbed to the developers in the 1960s. It was replaced by a block of offices (later converted to flats) with a pub on the ground floor. The pub has now become a restaurant and a flower stall occupies the pub's forecourt.

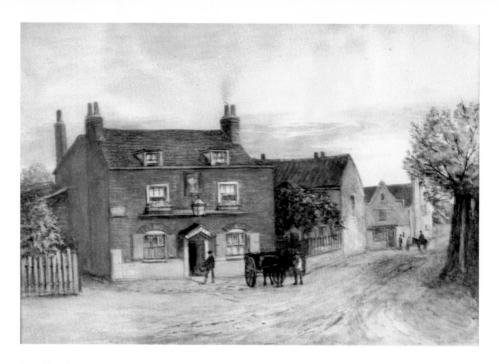

The Feathers

The first Feathers pub on the corner of Hogarth Lane and Devonshire Road, painted by
J. T. Wilson in 1869. At the turn of the century a new Feathers pub was built beside it in
an exuberant Victorian style, leaving the old pub to become a boot-maker's shop. The pub
survived the widening of Mawson Lane, shown in this 1930s photograph looking west, but
could not survive the building of the A4 and the Hogarth roundabout in the 1950s.

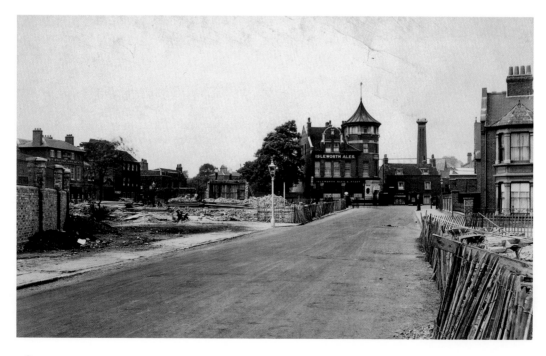

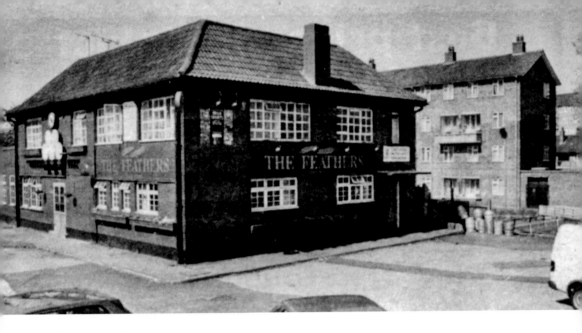

The Modern Feathers

So the Victorian pub had to go, but was rebuilt in 1960 in a considerably plainer style, on the north side of the A4, overlooking the roundabout, as shown in this newspaper photograph taken in the 1990s. But even this could not last, and it was pulled down in 1999 to make way for a building that was initially a showroom for vintage cars but is now used as offices. The modern photograph demonstrates the amount of street furniture generated by road junctions.

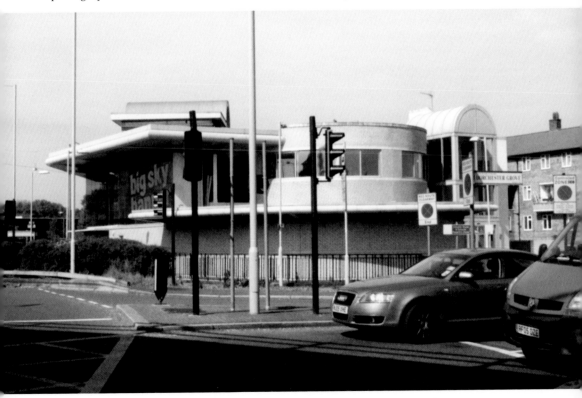

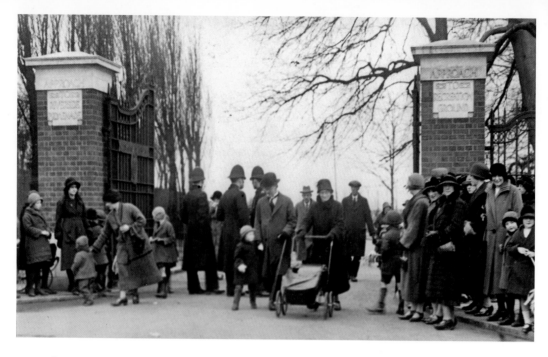

The Entrance to Duke's Meadows

The handsome entrance gates to Duke's Meadows on the official opening day in June 1926. Three years earlier, the Chiswick Urban District Council had bought 200 acres of riverside land from the Duke of Devonshire to preserve it as open space for playing fields and recreational areas. A promenade walk, bandstand and children's play area were created. The modern photograph shows the gates are not used as much now, except on Sundays for the regular farmers' market.

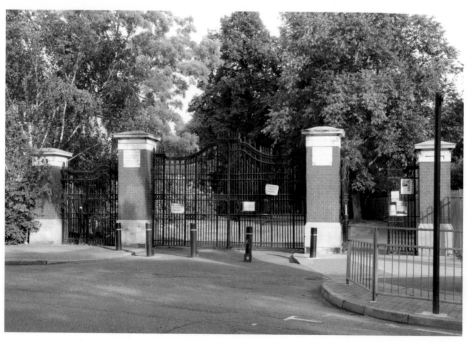

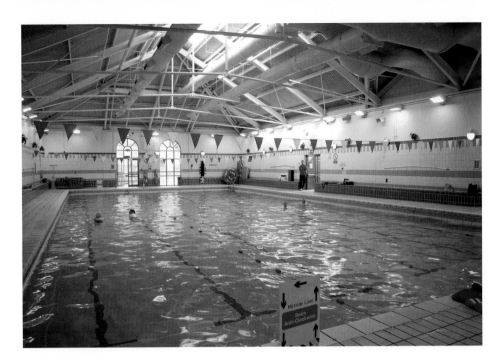

Open-Air Pool

The photograph below shows bathers enjoying the summer weather at the swimming pool in the 1920s. The pool in Edensor Road was opened in 1910, but as it was an outdoor pool it was only usable for part of the year. It finally closed in 1981 and a new indoor pool was opened ten years later as part of a housing development. In 2010 it was refurbished to provide a new fitness centre.

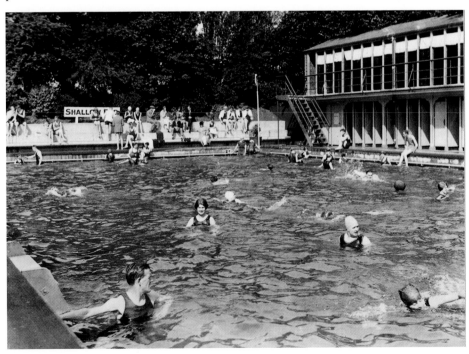

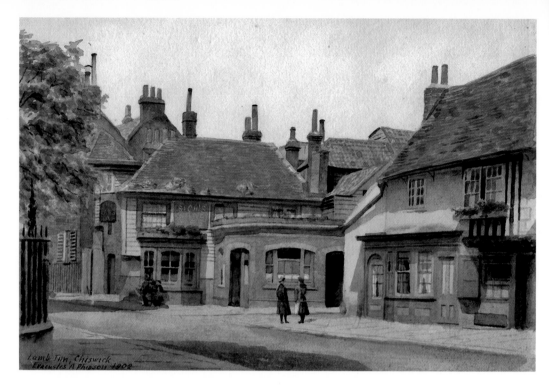

Lamb Tap

The Lamb Tap in Church Street, shown in a watercolour of 1902 by Evacustes A. Phipson. The pub was attached to the Lamb Brewery run by the Sich family. It closed in 1909, and became a private house. The building on the right in the painting was also a Lamb Brewery pub, the Old Burlington, probably one of the oldest surviving buildings in Chiswick. It lost its licence in 1924 and was then divided into two houses.

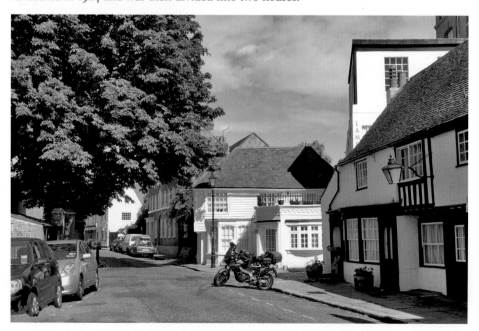

Shops and Shopping

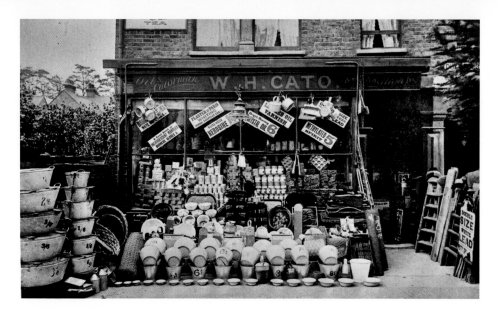

Cato's First Shop

William Henry Cato rented an empty shop at Number 46 Duke Road (then called Bolton Gardens) as an oil and colour merchant in 1901 – he was only twenty-two years old. The business prospered and he was able to open a second shop at Number 406 High Road in 1905. This was the beginning of a chain of thirty-four hardware stores set up and run by the Cato family. The original shop in Duke Road has been converted into a private house.

(On previous page) Allwright's Shop

Allwright's recently opened car-hire shop on the corner of Belmont Road and the High Road in 1925. It was replaced by a new office block and shops in the 1980s.

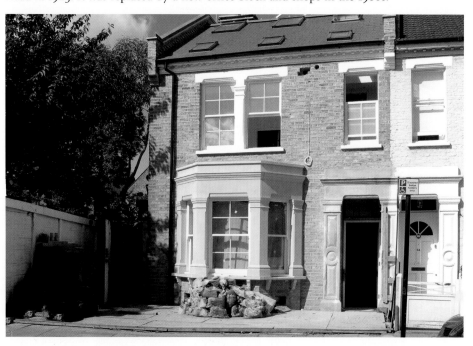

Caught's Butchers

The photograph below shows Robert Caught's shop at Number 396 High Road in the 1950s, a few years before it closed and was replaced by the modern parade of shops which included Chiswick's first Waitrose store. Caught's shop was established in the mid-nineteenth century. Meat was delivered on the hoof and slaughtered at the back of the shop. As they were opposite the cricket pitch on Turnham Green, Mr Caught offered a prize of a leg of mutton to any lucky cricketer who hit a ball into the shop.

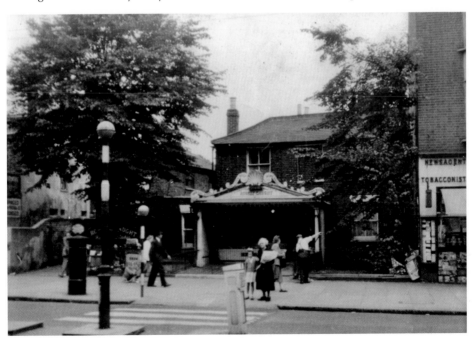

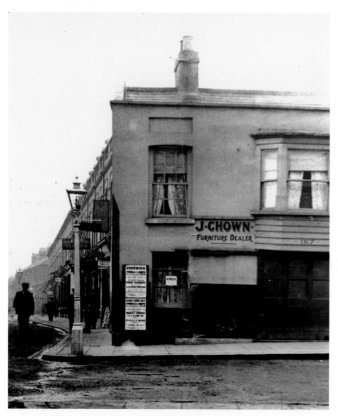

Joseph John Chown

Chown's shop on the corner of Devonshire Road and the High Road in the 1920s. Mr Chown set up as a furniture dealer at Number 167 in 1920. Next door at Number 169 was Mrs Elton's Dining Rooms, offering tea, coffee, cocoa and chops, according to the advertisement in her window – so Chiswick High Road had places to eat even then! Devonshire Road offered a wide range of shops; looking down the road towards the turning for Prince of Wales Terrace there were a fishmonger, a confectioner, a cycle engineer, an outfitter, a grocer and another furniture dealer. In 1929 Numbers 167 and 169 were demolished and replaced by the buildings shown in the modern photograph.

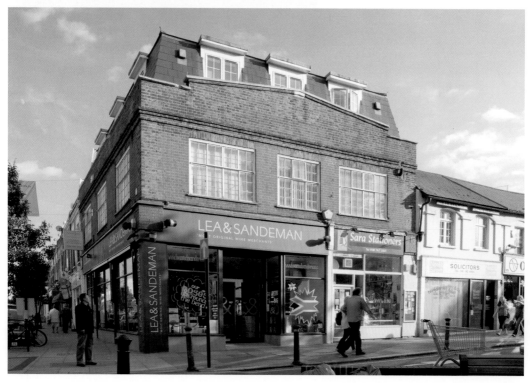

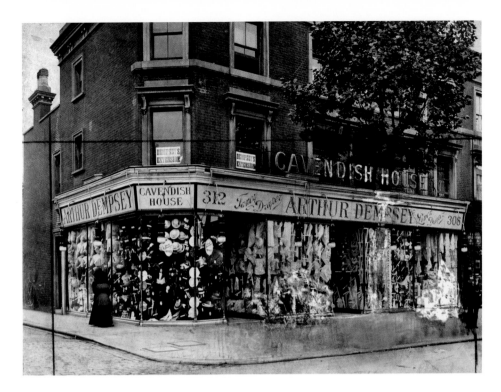

Arthur Dempsey

Arthur Dempsey set up as a 'Fancy Draper' at Cavendish House, on the corner of Clifton Gardens and the High Road, in about 1902. The damaged but rare photograph above shows the shop a few years later. In 1927 Lloyds Bank Limited took over the building and established a local branch of the banking chain. They have remained in the same building ever since, although the frontage has been altered several times since 1927.

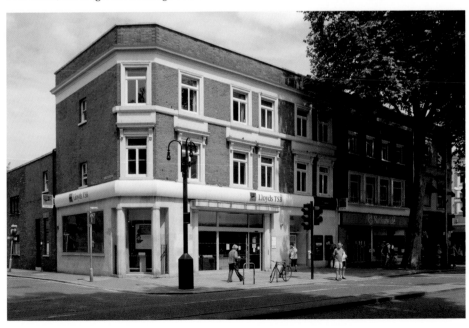

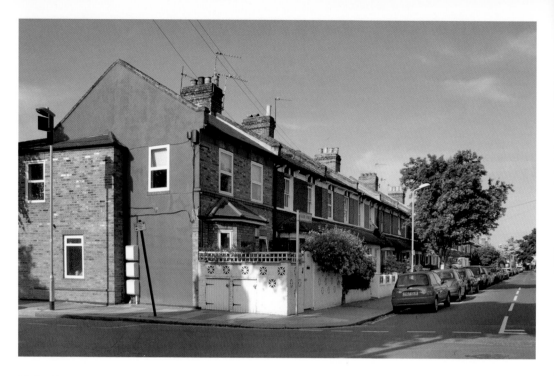

Glebe Street

When the Glebe estate was built in the 1870s there was provision for small shops on the corners of many of the roads. The confectioner's shop on the corner of Glebe Street and Duke Road shown in the postcard below was typical of many similar shops. It later became a tobacconist, and in the 1970s and 1980s sold pianos and other musical instruments. Eventually a bay window replaced the shopfront, a garden wall was built, and it became a private house.

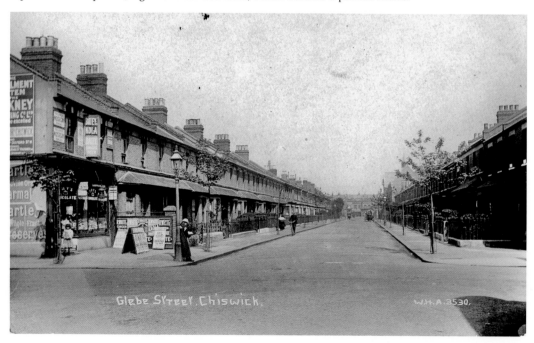

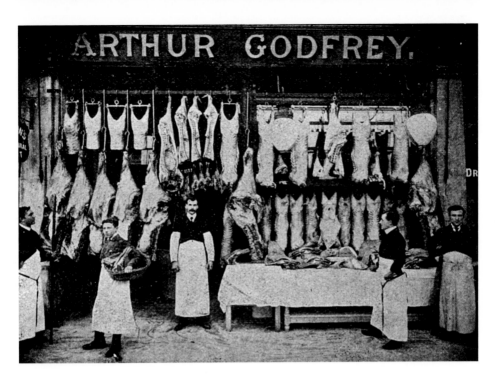

Arthur Godfrey

Godfrey's butcher's shop was established at Number 32 High Road in about 1903, and this postcard was sent in 1905; it reads 'Dear Ern, am sending a small leg, kindly accept same'. The shop would now be an environmental health officer's nightmare, with carcasses hanging in the air along the open shop front. It remained a butcher's shop up until the Second World War, then became a builder's premises and later a delicatessen, which has now closed.

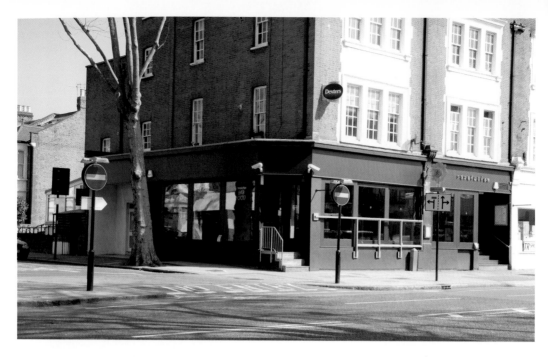

Alfred Goodwin

The postcard below is an early view of Alfred Goodwin's ironmongery store at Number 20 High Road, on the corner of Prebend Gardens, one of the new shops created when Young's Corner was redeveloped in the 1890s. The display of goods outside would be arranged every morning and carefully stored inside the shop overnight, when the large windows allowed passers-by to see the range of goods stocked. It remained an ironmonger's until the 1950s, and the premises are now Revolution Vodka Bar.

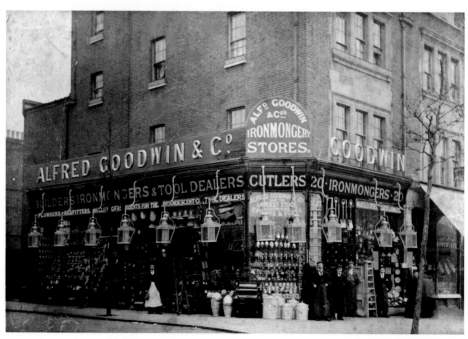

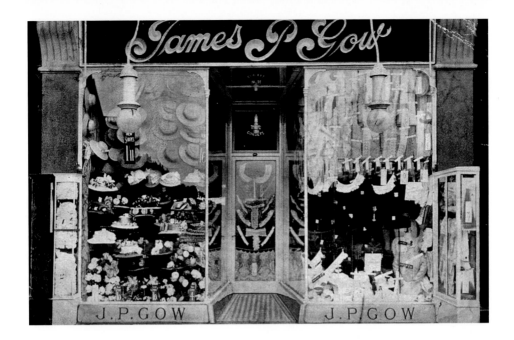

James Gow

James P. Gow opened his fancy drapery shop at Number 82 High Road in about 1903. This postcard was sent in 1911 in thanks for a hat 'received quite safely'. Although his windows were relatively small, he still managed to display an amazing variety of hats, collars and other items. Mr Gow moved on at the beginning of the First World War, but the shop continued as a draper's through the 1940s and 1950s, expanding into Number 80. It later became a cocktail bar called Potion, recently closed.

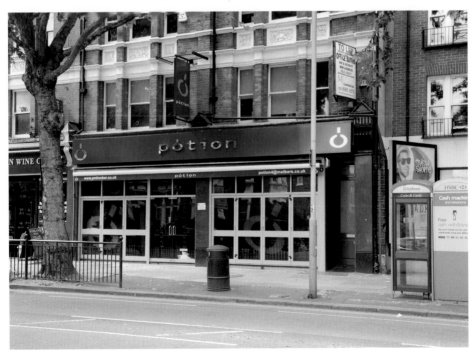

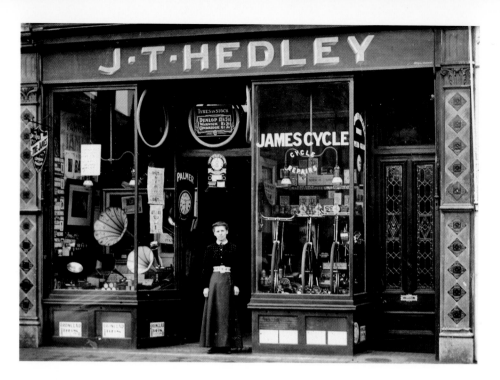

John Thomas Hedley

An early postcard of Mr Hedley's shop at Number 610 High Road which opened in about 1909, combining a cycle-repairing business with selling gramophones. He moved with the times and expanded his business as a cycle and motor engineer. In the 1960s Lovell Construction built their six-storey HQ here, and it is now a building site yet again, so the modern photograph shows that there are still cycle shops on the High Road. This one is Action Bikes at Number 176.

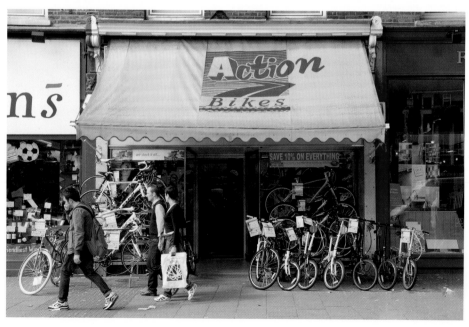

Alfred Huggett

The photograph below shows Mr Huggett's shop at Number 33 Sutton Lane in 1908. He had set up his bakery and post office in about 1903. He moved on before the First World War and the new shopkeeper dropped the bakery side of the business and ran it as a post office and stationer. Later it became a sweet shop, then the premises of a builder, but eventually it was turned into a private house, although the shape of the arched shop windows and delivery doors has been retained.

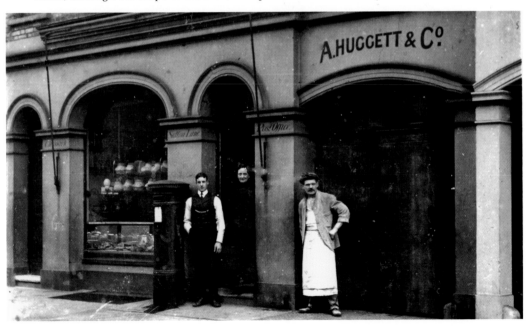

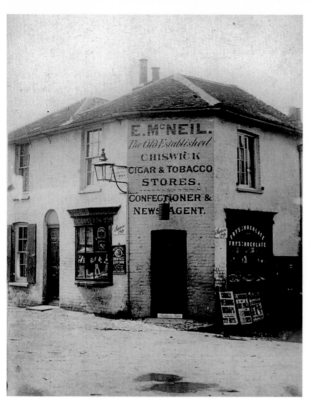

Mrs McNeil's

A postcard of about 1903 showing Mrs Emma McNeil's long-established tobacconist shop on the north-west corner of Church Street, sandwiched between the entrance to Page's Yard and Burlington Lane. Above the door hangs the traditional sign of stylised tobacco leaves which denoted a tobacconist's shop, just as the three golden balls signified a pawnbroker's. The shop disappeared from the records, and it is marked as a 'ruin' on maps in 1950 and 1960. There was another tobacconist's shop just round the corner in Burlington Lane; both were demolished in the late 1960s and housing was built on the site, in a Georgian style to blend with the old buildings of the George & Devonshire pub next door.

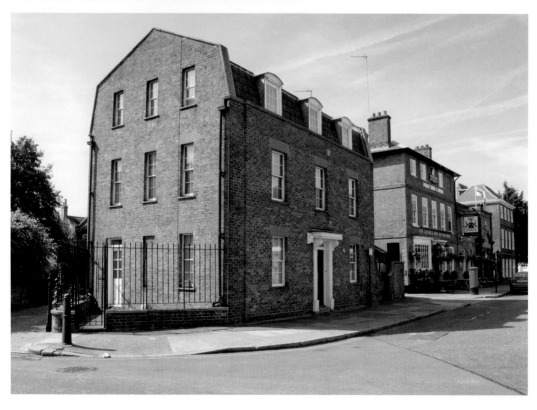

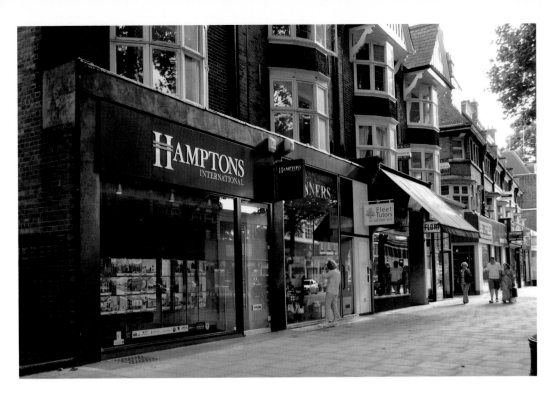

Mylo's

The photograph below shows Mylo's café and ice cream parlour at Number 253 High Road in the early 1980s, just before it closed. It was opened in the late 1930s in premises that had formerly been a grocer's, and became a favourite with many generations of local children. The shopfront was demolished in April 1983, but its name can still be seen lettered along the edge of the pavement marking the site of the shop.

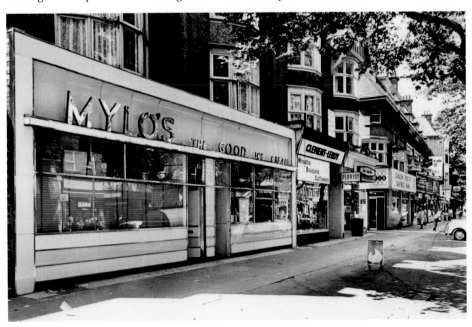

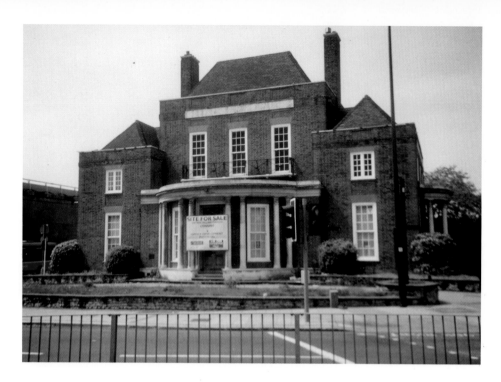

NatWest Bank

The NatWest bank on Chiswick roundabout in 1995, soon after it closed. Originally a branch of the National Provincial Bank, it was erected at the southern end of the Great West Road in 1926, soon after the road was built. It was designed by F. C. R. Palmer, an architect famous for bank buildings. It later became the NatWest after a bank merger in 1970. There have been a number of unsuccessful proposals for redeveloping the site, which remains shrouded in hoardings.

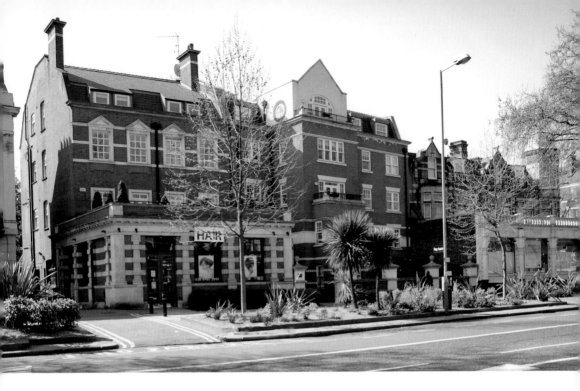

Parr's Bank

Parr's Bank was established at Number 23 High Road in about 1905, next door to the Chiswick College of Music, as shown in the postcard below. As a small bank it was later taken over by the Westminster Bank, and after another bank merger became a NatWest branch. It closed in the mid-1990s. The building was extended and redeveloped as a block of flats called Parr Place in 1999, with a hairdresser's in the front extension, which was the original banking hall.

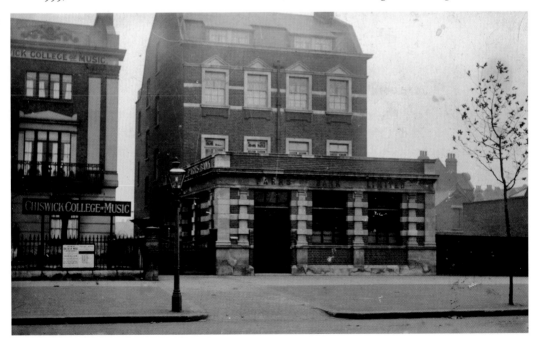

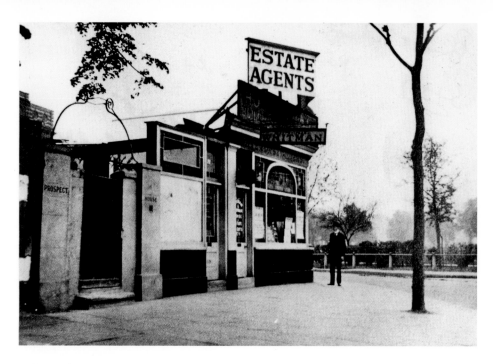

Whitman's Corner

The office of Whitman's, builders and estate agents, at Number 279 High Road, on the corner of Heathfield Terrace, in the 1920s, before new offices and shops were built on the corner in the 1930s. The entrance gate on the left led to Prospect House, which is still there but embedded in the later development of the corner. This is still colloquially known as Whitman's Corner, although Whitman's themselves moved to Turnham Green Terrace in the late 1980s.

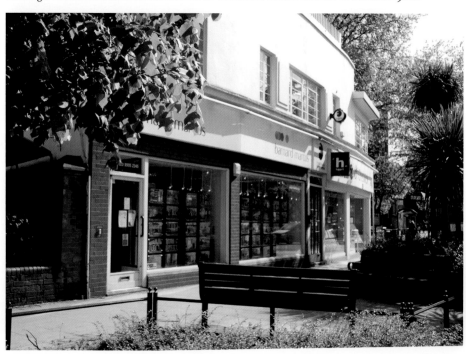

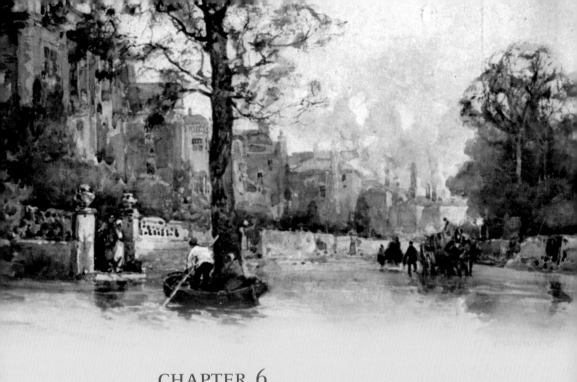

CHAPTER 6

Disasters

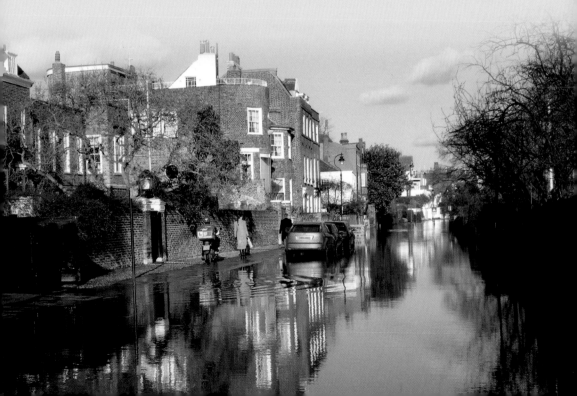

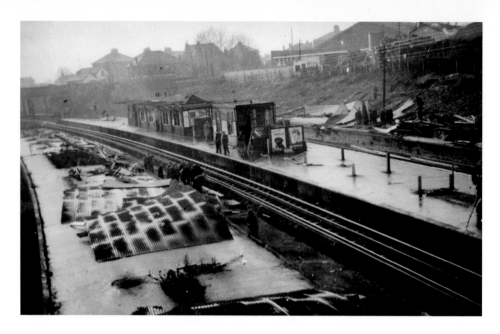

Gunnersbury Station after the West London Tornado

A tornado stormed through the area on the evening of 8 December 1954, leaving a trail of damage in its wake. At Gunnersbury station the ticket collector's hut blew away, the corrugated iron roof of the platform buildings collapsed, burying fifteen passengers as it fell, and the roof of the garage in the station forecourt was blown right across the High Road. The modern photograph shows the station, now reduced to two platforms, from the other end.

(On previous page) Floods on Chiswick Mall

High tides in the past frequently caused the River Thames to flood over the roadway along Chiswick Mall. Nowadays the Thames Barrier reduces the number and severity of the floods, but unwary motorists can still be caught out.

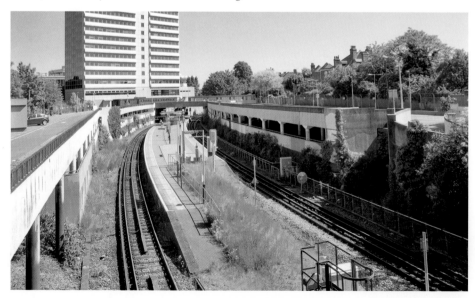

Fire at Sanderson's Factory
The packing and distribution department at Sanderson's wallpaper factory after the fire in 1928. The fire started in a store room on the second floor on Thursday 11 October, and despite the efforts of the Chiswick brigade and fire brigades from all the surrounding areas, the whole factory was soon alight. The paper, varnish and oils with which the building was stocked were all feeding the flames. Flame40 feet high and a pall of black smoke were visible all over West London, attracting huge crowds of sightseers – extra police had to be drafted in to control them. Fortunately, as the fire broke out at lunchtime there were not many staff in the building and all escaped safely, although several firemen had to be treated for smoke inhalation and burns. The heat was so intense that the glass in the windows melted and hung in festoons, the iron girders were twisted into fantastic shapes, the roofs crashed in and several walls collapsed. A week later, when the fire was finally extinguished, the buildings were a smouldering ruin. Amazingly the factory buildings on the other side of Barley Mow Passage had not been badly damaged, so a limited range of wallpapers could be produced, but Sanderson's decided to open a new factory at Perivale in 1929 and left the area. Their Chiswick buildings were partially rebuilt and are now used for small business units. The modern photograph shows the same area as the old one, which was never re-roofed, and at the far end the five-storey building which was reduced to just one storey by the fire.

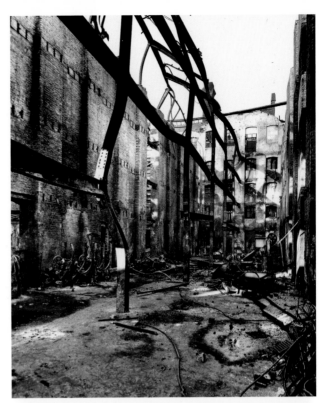

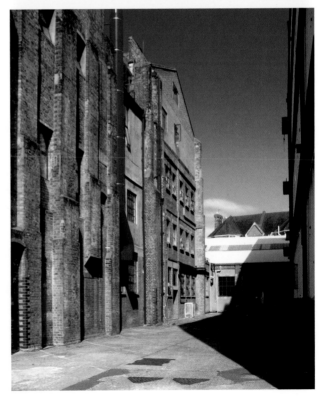

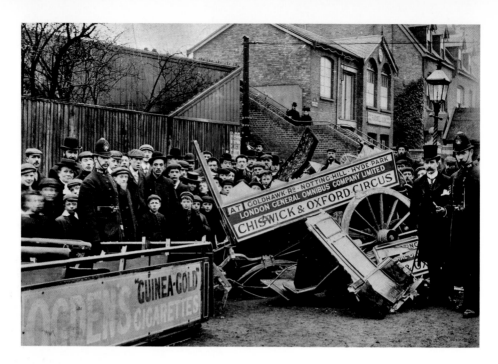

Horse Bus Crash

In February 1901 there was a horrific accident when a horse bus was struck by a goods engine on the level crossing in Grove Park Terrace. An LGOC staff member travelling inside the bus was killed instantly, the driver of the bus died from his injuries two days later, and the conductor was seriously injured. Both horses were killed outright and the bus was completely wrecked. The crossing now has automatic barriers, signal lights and a bridge for pedestrians.

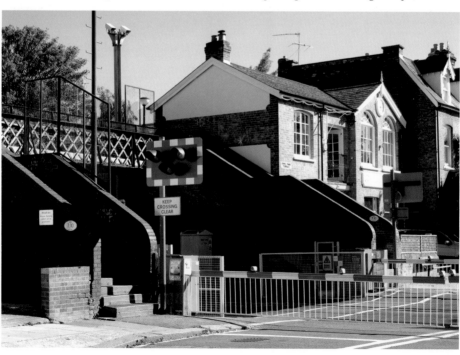

First World War Tank

A lantern slide of Chiswick's tank on the corner of the High Road and Sutton Lane North, taken in 1923, with the tower of Christ Church in the background. This 'retired' tank had been presented to the people of Chiswick in 1920 as a reward for their fundraising efforts during the First World War. It had arrived by train at Chiswick station in Grove Park, then trundled up Sutton Court Road at a stately one and a half miles an hour and been manoeuvred into position on a specially built brick ramp on the corner of Turnham Green. It was not universally popular and was removed and cut up for scrap in 1937; the brick ramp was demolished, and the present rockery was created on its site.

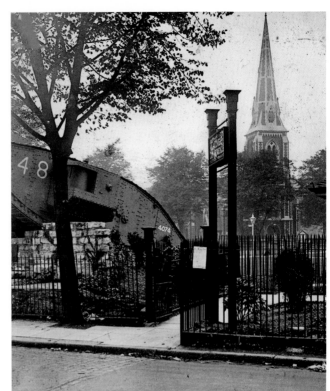

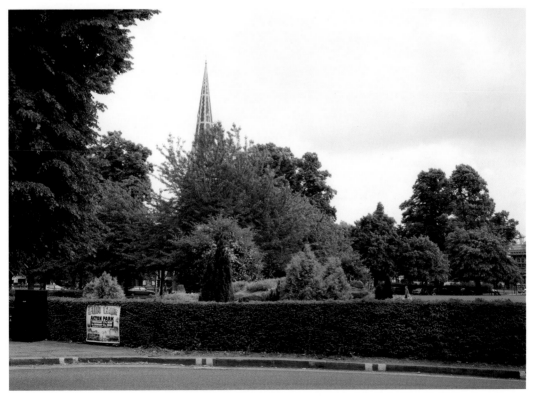

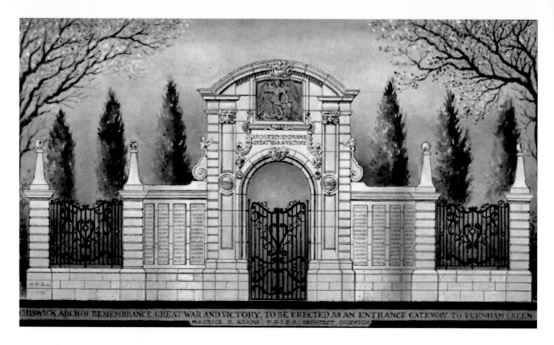

CHISWICK ARCH OF REMEMBRANCE, GREAT WAR AND VICTORY, TO BE ERECTED AS AN ENTRANCE GATEWAY TO TURNHAM GREEN
MAURICE B. ADAMS F.R.I.B.A. ARCHITECT, CHISWICK

Memorial Arch for Turnham Green

A plan for an archway in memory of the Chiswick servicemen killed in the First World War, designed by local architect Maurice B. Adams. However, the committee decided the money raised should instead be used for the provision of housing for disabled ex-servicemen, and the Memorial Homes were built in Burlington Lane in 1922. A small obelisk was erected on the corner of the Green in 1921 as a focus for remembrance.

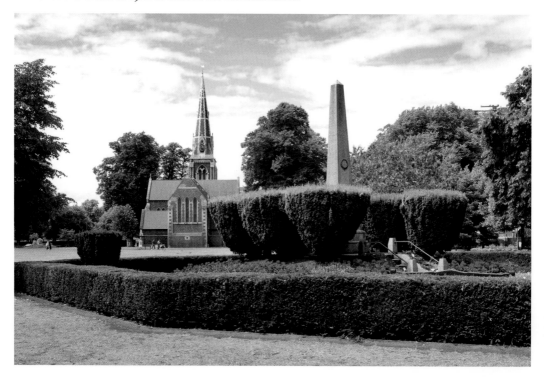

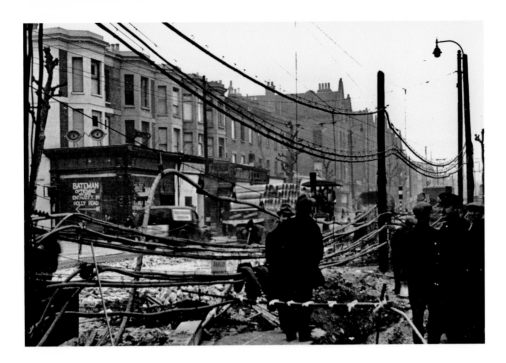

Air Raid Damage

When a high-explosive bomb fell at the corner of Duke's Avenue and the High Road on 19 February 1944 it killed three people, brought down the trolley-bus wires, cut the gas main and the telephone and electricity cables, and caused widespread damage over a wide area. It was eight days before the High Road was open for traffic again. The modern photograph shows that the shop on the corner of Holly Road is still an opticians over sixty years later.

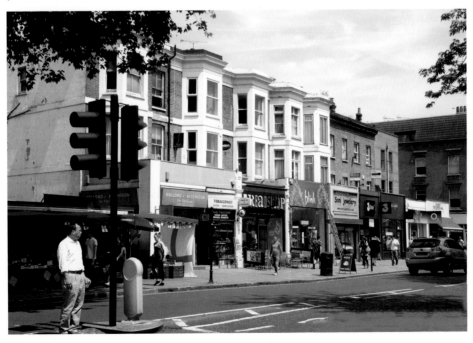

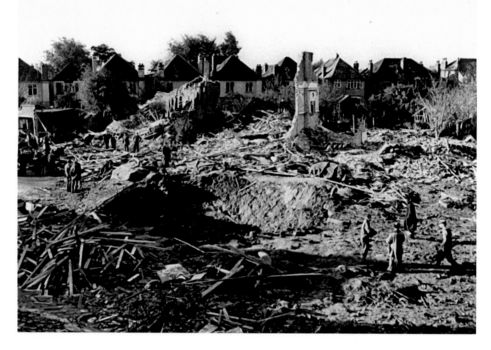

The First V2

The crater in Staveley Road with the backs of the houses in Burlington Lane in the background, after a V2 rocket landed there at 6 p.m. on Friday 8 September 1944. This was the first V2 to fall in England and it left a huge hole in the road, and demolished eleven houses outright, damaging hundreds more. Remarkably, only three people were killed and another twenty-two injured. The site is now marked by a memorial stone unveiled in September 2004.

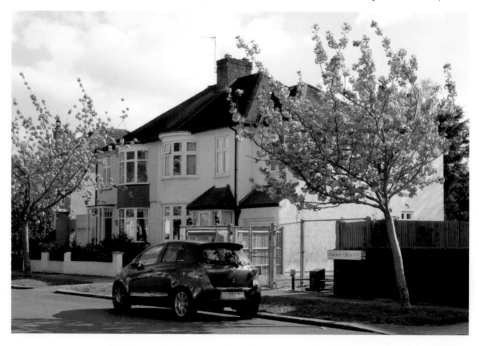

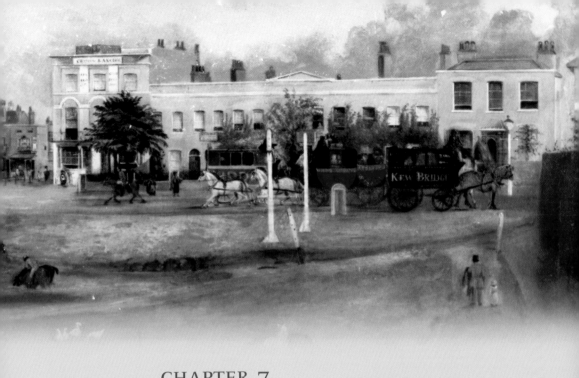

CHAPTER 7

Transport

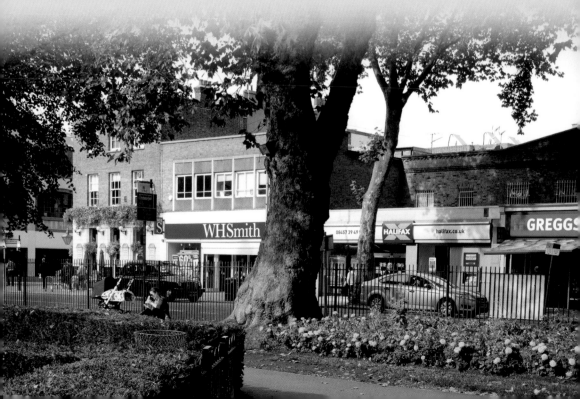

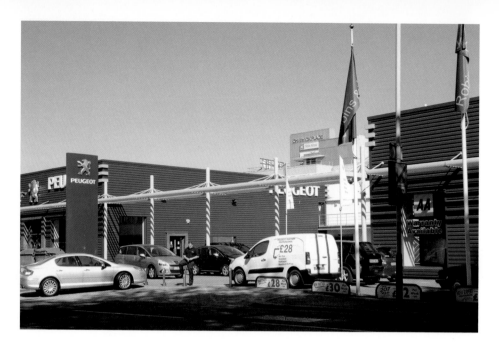

The Changing House

The 1893 photograph below shows the Changing House, a small eighteenth-century brick building on the north side of the High Road, just east of Gunnersbury Avenue. It was originally used as stabling for the relay horses for the long distance coaches from London to the west. It later became a wheelwright's premises, and was finally swept away in the 1920s when the Great West Road was built, and replaced, appropriately enough, by a garage.

(On previous page) Chiswick High Road

Traffic on the High Road, shown in an 1840s painting. The modern photograph shows the same stretch of the High Road with the Crown & Anchor pub on the left and the architrave of Wellington Terrace visible above Greggs shop.

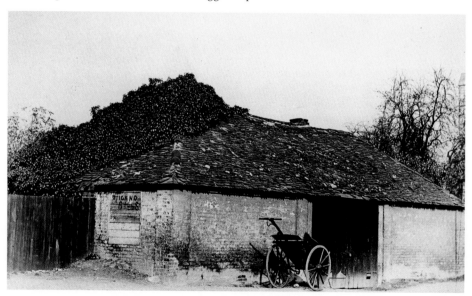

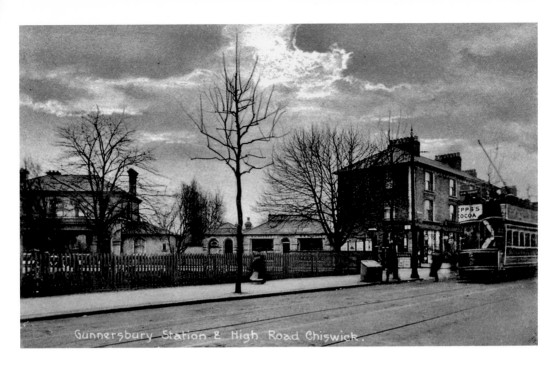

Gunnersbury Station & High Road Chiswick.

Gunnersbury Station in the early 1900s

The station opened in 1869 on the newly built line to Richmond. It originally had five platforms, but in 1932 it was redeveloped with a single island platform for the District and North London Line trains, and the link to the Hounslow Loop line was closed. Then in 1966 the station house and the buildings in the station forecourt were swallowed up by the tall office block built for IBM (now the British Standards Institute), leaving only a small ticket office at street level.

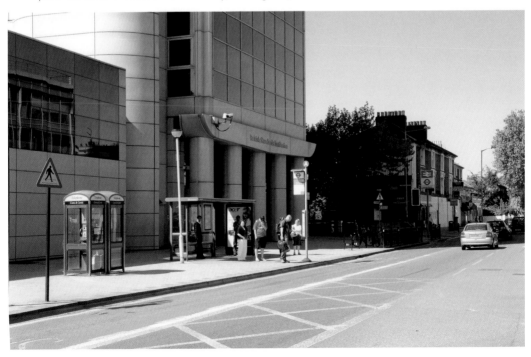

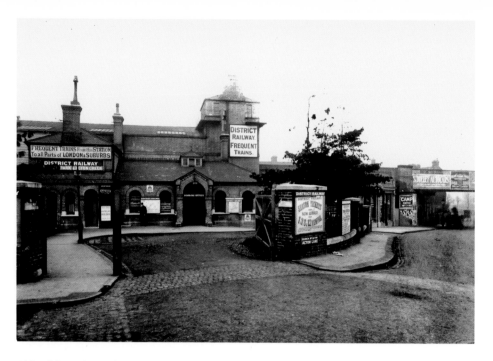

Chiswick Park Station

The station in about 1901, when it had a gated forecourt. It was opened as Acton Green Station in 1879 when the District Line was extended from Turnham Green to Ealing. In 1887 it became Chiswick Park and Acton Green, and did not drop the Acton Green until 1910. When the Piccadilly Line was extended from Hammersmith to Acton Town in 1932, requiring two extra tracks, the station had to be rebuilt. The new station was designed by the famous architect Charles Holden.

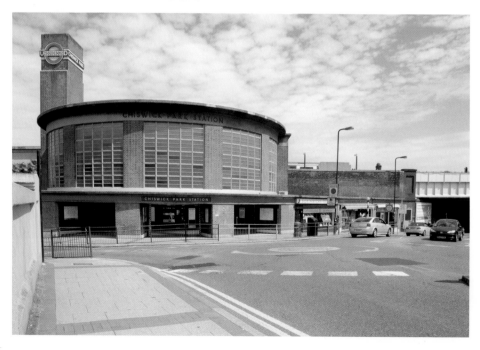

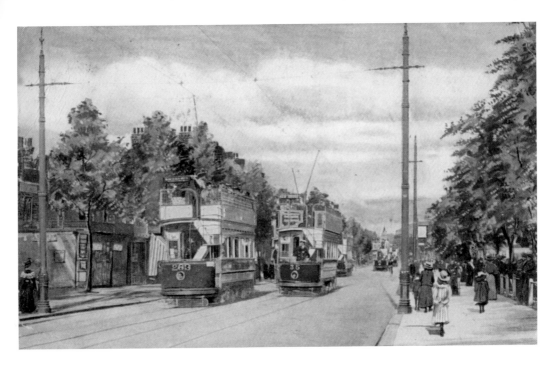

Trams

Trams beside Turnham Green Common in about 1905. The electric tram service along Chiswick High Road to Kew Bridge was inaugurated in April 1901, and was extended further westwards later that year, replacing the horse-drawn trams. These are the routes which later became those of the modern buses Numbers 237 (the red tram) and 267 (the blue one). The trams brought public transport within the reach of ordinary people at only one half penny per mile.

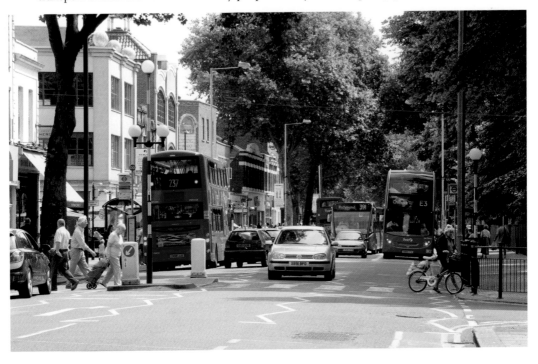

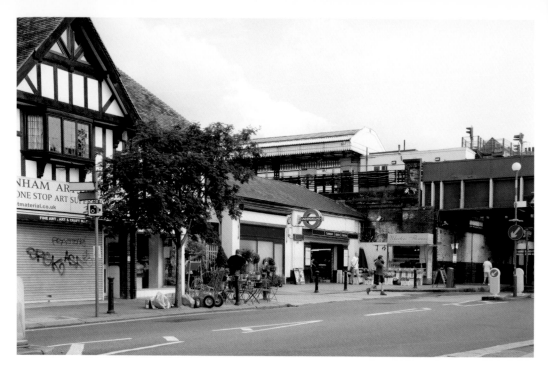

Turnham Green Station

The station was opened in 1869 on the line to Richmond. Initially the station only had two platforms, with the up line and the down line running between them. The postcard below shows it shortly after it had been remodelled in 1911 with two island platforms serving four sets of lines and allowing for an increased number of trains, as by then trains were running through to Ealing and Hounslow. The shops alongside the station were redeveloped in the 1920s.

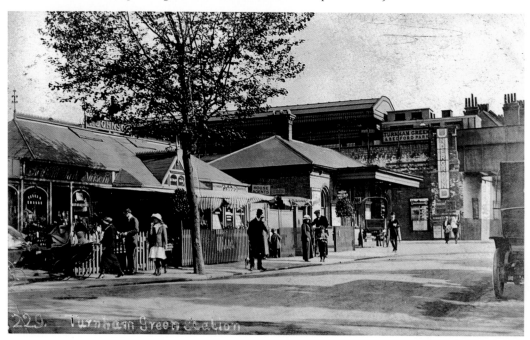

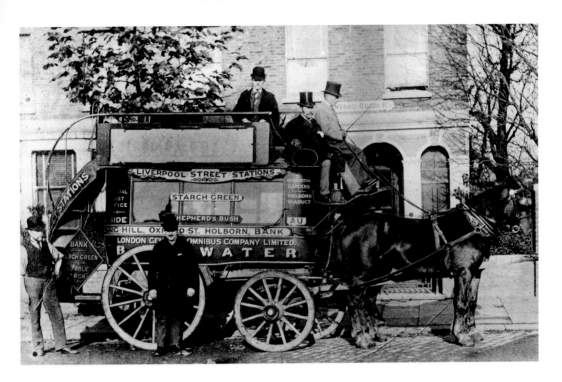

Horse Bus

A horse-drawn bus outside the London General Omnibus Company's premises in Stamford Brook Road in the mid-1880s, on the route of the modern Number 94 bus. The company's initials can still be seen in the raised stonework above the doorway to the left of the tree. On the right of the tree is the entrance which led to the stabling for the horses. Later the premises became a motor-car garage and finally a private house.

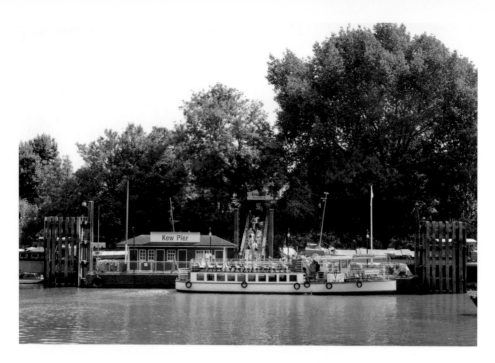

Paddle Steamers at Kew Pier

The early lantern slide below shows passengers boarding paddle steamers at Kew Pier. As freight traffic on the river decreased during the twentieth century so passenger traffic took over as the main use of the Thames. Kew Pier was, and still is, a regular stop for river cruises from the centre of London out to Richmond and Hampton Court. The Steam Packet pub in the background of the old photograph is now a branch of the restaurant chain Café Rouge.

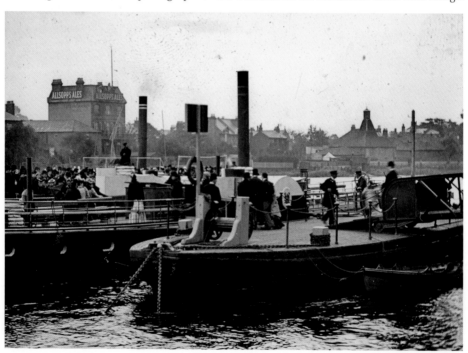

Chiswick Station

A goods locomotive pulling a train of empty coaching stock through Chiswick station in 1959. The station was opened in 1849 on the newly built line from Hounslow to Barnes, the first railway to come through Chiswick. The station house was designed by Sir William Tite, the architect of the Royal Exchange, and is now used by a design and advertising agency. The line was electrified in 1916 and the modern photograph shows one of the electric multiple units that provide a regular service.

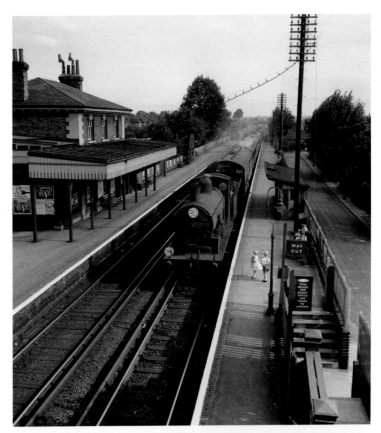

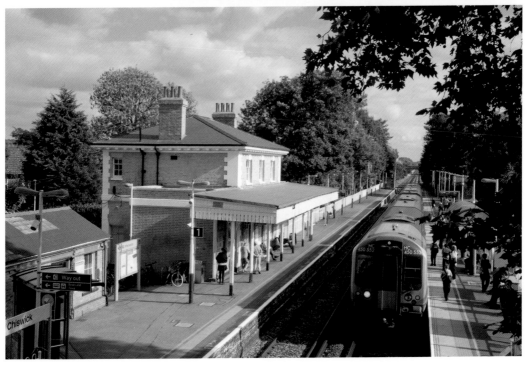

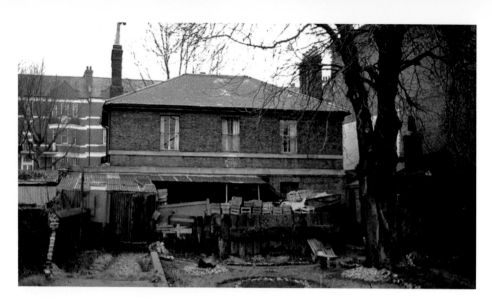

Hammersmith and Chiswick Station on the High Road

Looking south across the area which was once the platform and tracks towards the back of the station house in the late 1960s. This was the terminus of the North and South Western Junction Railway, opened in 1857 from South Acton. It carried passengers as well as freight from 1858 until 1917, and then continued in use for coal until 1965. The houses and flats of the Ravensmede development were built on the site of the railway in 1980.

Acknowledgements

We acknowledge our indebtedness to all who have written on the history of Chiswick in the past, and in addition our thanks go to the following for their help: James Marshall, Local Studies Librarian for the London Borough of Hounslow; Vanda Foster, Curator of Gunnersbury Park Museum; Gillian Clegg; Peter Downes and Brian Prior for allowing us to use postcards from their extensive collections; Richard Clarke and David Wells for their expert knowledge of trams and buses respectively; Vince Marsh at New Chiswick Pool; and all the helpful staff at the archives we contacted.

The majority of old photographs in this book come from the collections at Chiswick Public Library and Gunnersbury Park Museum, and we thank the London Borough of Hounslow for allowing us to use them. Where these were copied from originals held by other institutions or individuals we should like to thank the following for permission to use their photographs: *Richmond and Twickenham Times* for photographs from the *Brentford and Chiswick Times*: images on pages 10, 23, 29, 34, 54, 59; Executors of the late John Gillham: 80; Arthur Sanderson & Sons: 43, 81. In some cases it has not been possible to identify the copyright holder, so we offer our apologies if we have unintentionally infringed anyone's copyright.

We are most grateful to the following for allowing us to use items from their collections: Richard and Tom Cato: 64; City of London, London Metropolitan Archives: 5, 7, 13, 33, 47, 48, 58 ; J. E. Connor of Connor & Butler: 96; Peter Downes: 16, 17, 19, 22, 26, 27, 31, 42, 45, 68, 69, 71, 74, 92; the late A. E. 'Dusty' Durrant by courtesy of the Prorail UK Collection: 95; London Borough of Ealing: 93; English Heritage, NMR: 36; Gunnersbury Park Museum: 35, 75, 81; Lloyds Banking Group Archives: 67; London Transport Museum: 82, 90; Don Maxwell: 79; The National Archives UK: 86; Brian Prior: 9, 21, 39, 46, 51, 52, 55, 72, 77, 89;

The modern photographs were all taken by Peter Hammond, apart from those on pages 19 and 79, which were taken by Peter Downes and Don Maxwell respectively.